BARKING & DAGENHAM

From Old Photographs

SYLVIA KENT

AMBERLEY

Acknowledgements

Grateful thanks are extended to Elizabeth and Donald Wallace, Norma Mallory, Eve and Bob Gladstone, Margaret Powell, Shirley Tolliday, Brian Evans, Tony Clifford, Clive Simpson, Kay and John Hayes, Brian Lynch, Shirley Mackey and others.

Warmest thanks are extended to Dame Vera Lynn, the Right Honourable George Carey, Sir Trevor Brooking, Professor Roy Greenslade, Billy Bragg, friends of the late Dudley Moore, Barry Hearn and Sheila Hatcher, Peggy Iris (one of the original Dagenham Girl Pipers), Karen Mahoney and members of the Band and Veterans' Association.

Many thanks to the mayoral office at Barking Town Hall and Dagenham Civic Centre for their interest; also to the family of the late Norman Gunby. Huge thanks to Oliver Rowe and Dave Hill at Ford Motor Company.

I'm indebted to the head teachers and staff of local schools, including the Sydney Russell School (formerly Dagenham County High), Barking Abbey, the Ford Endowed School, Marsh Green Junior (Ann Savage) and Dagenham Park Church of England School (formerly Marley/Priory Schools), Simon Weaver and Jan Wood.

Michael Adkins, editor of the *Barking and Dagenham Post*, has been kind in publishing features advertising my book.

Lastly, I thank Dorothy Lockwood, Bill George, John Blake and, of course, the staff at Eastbury Manor House and Valence House Museum, particularly Linda Rhodes, Clare Sexton and Leanne Woodward.

With love and thanks to Peter, Sally and Jennifer.

First published 2014

Amberley Publishing
The Hill, Stroud, Gloucestershire, GL5 4EP
www.amberley-books.com

Copyright © Sylvia Kent, 2014

The right of Sylvia Kent to be identified as the Author of this work has been asserted in accordance with the Copyrights, Designs and Patents Act 1988.

ISBN 978 1 4456 2244 6 (print)
ISBN 978 1 4456 2267 5 (ebook)

British Library Cataloguing in Publication Data.
A catalogue record for this book is available from the British Library.

Typesetting by Amberley Publishing.
Printed in Great Britain.

Introduction

On 1 April 2015, the residents of the London Borough of Barking and Dagenham will mark the fiftieth anniversary of the merging of these two former municipal boroughs. In 2001, the official Heritage Strategy Programme adopted by the council was set in motion, and through the Valence House Museum the wider world learned more of the borough's rich history.

Now, half a century on from the amalgamation on 1 April 1965, the borough will commemorate the union of these incomparable communities, each with its own unique history. The two settlements of Barking (Berica's people) and Dagenham (Daecca Ham) existed close to the Thames and Roding rivers long before the region's history was properly recorded. Prehistoric hand axes and flint relics have been found in local areas, later known as Ripple Road, Gale Street, Becontree Heath and Barking Creek.

Perhaps the most fascinating object to be discovered from the low-lying Dagenham marshland was the carved wooden figure popularly known as the 'Dagenham Idol'. This was believed to have been buried around 4,000 years ago. It was discovered during construction in 1922 of the Becontree Estate.

We know something about the occupation of the area from the discovery of Roman and Saxon artefacts, including pottery vases and stone coffins found in

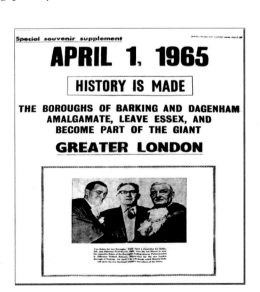

Two robes for two boroughs. Until 1 April, Cllr Joe Butler (*left*) and Alderman Fred Brown (*right*) were the last mayors to wear the respective robes of the borough's leading citizens. Pictured centre is Alderman William Bellamy, mayor-elect for the new London Borough of Barking. On 1 April, he will decide which mayoral robe will adorn the new Barking's number one citizen of the future.

archaeological digs in the district. The Roman presence in the Dagenham area is mainly gleaned from their building of the Great Essex Road, which runs to the north of Dagenham through Chadwell Heath and onward to the nation's oldest recorded town Colchester (Camulodunum).

The Barking historian, Fred J. Brand (1857–1939) recorded details of the artefacts discovered on the site where a Roman camp was believed to have existed at Uphall (now Redbridge). Roman bricks and tiles were reused in the building of Barking Abbey around AD 666 by Erkenwald, later 4th Bishop of the East Saxons. His sister, Ethelburga, became its first abbess. Both were later canonised.

Barking Abbey became one of England's wealthiest monasteries and, although it was destroyed by the Vikings in AD 870, it was rebuilt a century later and is mentioned in the Domesday survey of 1086. As well as the titular Manor of Barking, there were numerous other properties under the ownership of the abbey, including properties in parts of Essex, Buckinghamshire, Surrey, Bedfordshire and Middlesex; also the ancient church in London of All Hallows by-the-Tower.

William the Conqueror came to live at Barking Abbey after the Battle of Hastings while his new home at the Tower of London was being built. The abbey was surrendered to the Commissioners of King Henry VIII in November 1539, being one of the last of the great monasteries to be closed down. Today all that remains is the Curfew Tower (rebuilt 1460) and the excavated abbey site (1911).

Barking once had the largest fishing fleet in the world. From the fourteenth century, there is reference to saltwater fishing by local men. While collecting information for his *Tour Through the Whole Island of Great Britain*, Daniel Defoe considered Barking to be 'a large market town, but chiefly inhabited by fishermen, whose smacks ride in the Thames, at the mouth of their river, from whence their fish is sent up to London to the market at Billingsgate, by small boats...'

Dagenham is well known due to the mighty Ford Motor Company, which began in the 1920s when the bleak marshland was developed by the clever industrialist, Samuel Williams. It was he who designed piling to provide foundations to support the weight of the enormous Ford factory. At the same time, London County Council was building the Becontree estate as 'Homes for Heroes' following the First World War.

For almost eighty-five years, the Dagenham Girl Pipers have brought a bright swirl of the Royal Stuart tartan and the wonderful sound of the bagpipes to thousands of events, first locally, then overseas, making them a household name, even today. Much is owed to their founder, the Revd Joseph Waddington Graves, whose dream turned into reality in the spring of 1930, when he chose a dozen eleven-year-olds to become Highland pipers.

The proximity of Barking and Dagenham to London made the area a convenient place to live for government officials and London merchants. Parsloes Manor, for instance, was owned by several Lord Mayors of London, such as Lord Chief Justice Denman, Sir Martyn Bowes and Sir Edward Osborne. Sadly, the Gascoynes and Fanshawes, great families in the past, are remembered now only by place names.

Homage is paid to previous historians, including Herbert Hope Lockwood, Norman Gunby, John O'Leary, James Howson, and currently, John Blake, William George, Brian Evans and Tony Clifford, all of whom have shared their enthusiasm and extensive historical knowledge.

Chapter One

Our Ancient Marshland

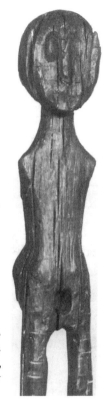

Right: Although many think of the borough as a relatively new community, relics prove that people lived here in Neolithic times. In 1922, when London County Council had already begun work in building the Becontree Estate, an intriguing figure (18 inches/45 centimetres high) carved from Scots pine, was discovered in the extensive marshland that spread from the River Thames. Dubbed the 'Dagenham Idol', archaeologists later carbon-dated the figure back some 4,000 years to around 2350–2140 BC. It is believed to have been buried as a fertility charm to entreat the pagan gods to provide a good harvest.

Below: A rhinoceros' jawbone was discovered from around 100,000 years ago. Neolithic flint implements were also excavated from numerous locations surrounding Barking and Dagenham, including Five Elms, Becontree Heath and Gale Street, with earthworks close to the area we now know as Rainham.

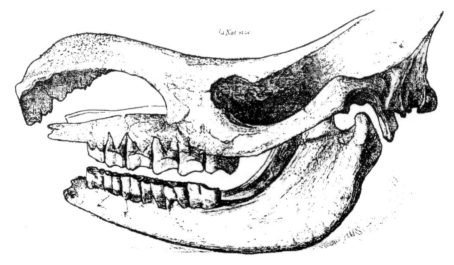

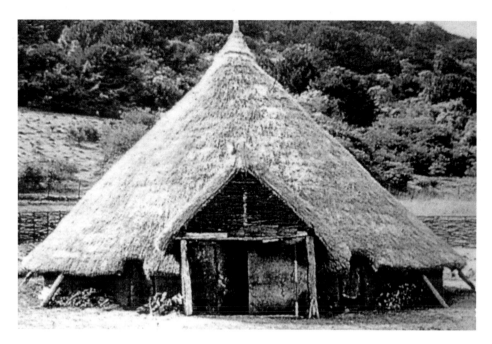

Around 2000 BC, when settlers sailed from Spain into the Thames estuary, they brought metalworking and trading skills. Celtic people crossed the Channel from *c.* 500 BC. Iron weapons and tools began to be used, but the structure of ancient Britain was still predominantly tribal at this time. The historian Norman Gunby's map (*opposite*) shows where some of the main British tribes lived and the type of round house believed to exist at the time. The Catuvellauni tribe settled on the north bank of the Thames and conquered the Trinovantes in what is present-day Essex.

The estimated extent of the Iron Age Camp at nearby Uphall. (*Image courtesy of Norman Gunby*)

6

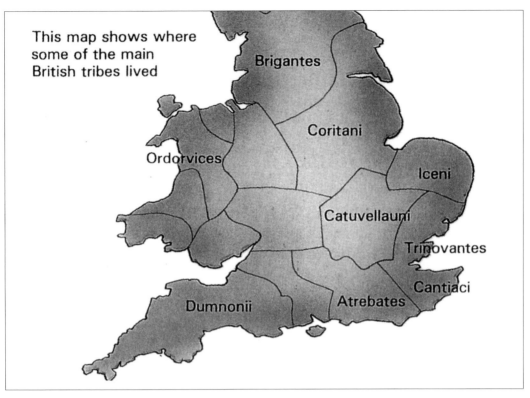

This map shows where some of the main British tribes lived

Brigantes

Coritani

Ordorvices

Iceni

Catuvellauni

Trinovantes

Cantiaci

Dumnonii

Atrebates

Map of British Tribes. (*Image courtesy of Norman Gunby*)

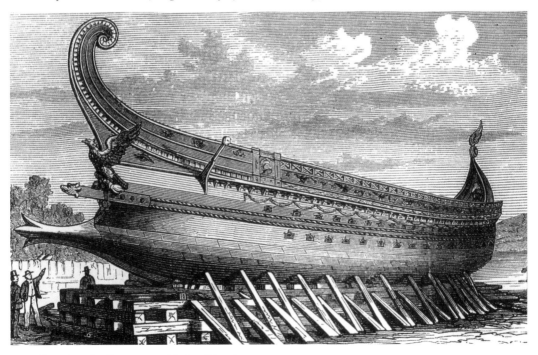

Drawing of a Roman warship in all its glory.

Left: Around 55 BC, Julius Caesar, who had by then conquered most of Gaul (France), invaded Britain, staying but a short time. He returned the following year and penetrated as far as what we now know as Hertfordshire. Ninety-seven years later, the Emperor Claudius added Britannia, as it was then known, to the Roman Empire and established a colony at Camulodunum (Colchester). An actor playing Roman General Aulus Plautius, in the 1931 historical paegeant to celebrate Barking's Charter of Incorporation, can been seen in this picture.

Below: Several Roman stone coffins were discovered in the area. This one was found on a site in Ripple Road during the 1920s. Such coffins were usually buried with customary grave goods. (*Image courtesy of Valence House*)

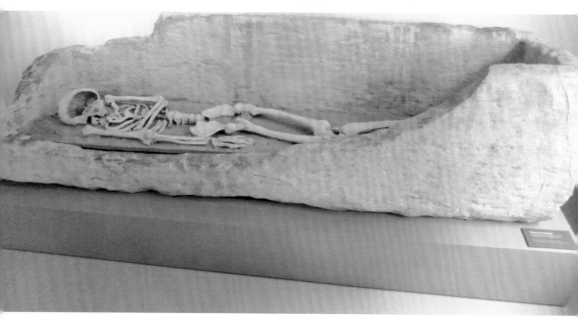

Roman fibula (brooch) found in the ruins of Barking Abbey after it was desecrated by the Vikings in the ninth century.

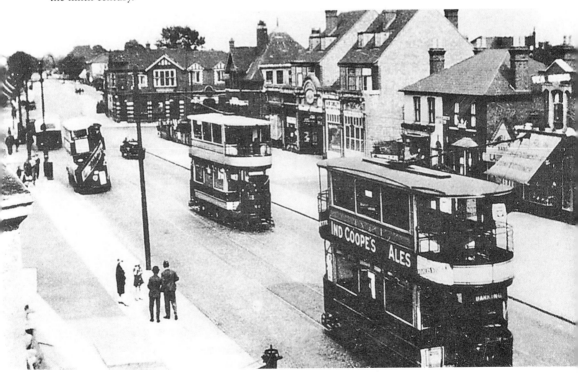

This 1930 view of the High Road at Chadwell Heath reminds us that this was the route of the main Roman road linking London (Londinium) to Colchester (Camulodunum).

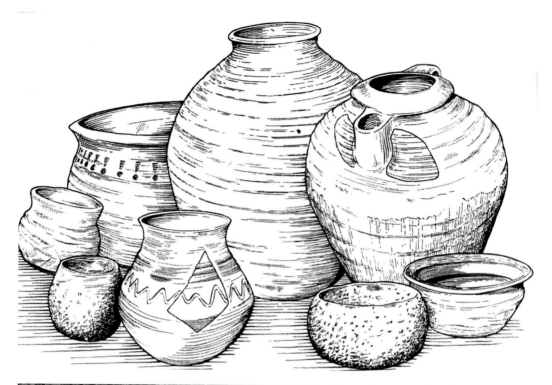

Above: Saxon pots found in the district.

Left: A 'modern' Viking.

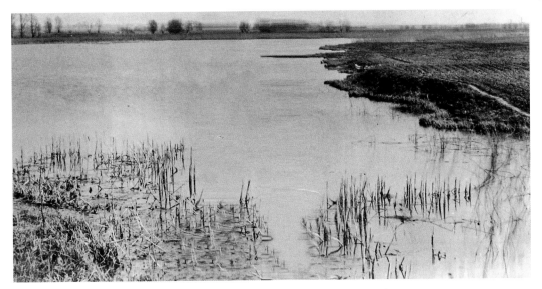

The desolate marshland along the Thames estuary before development began.

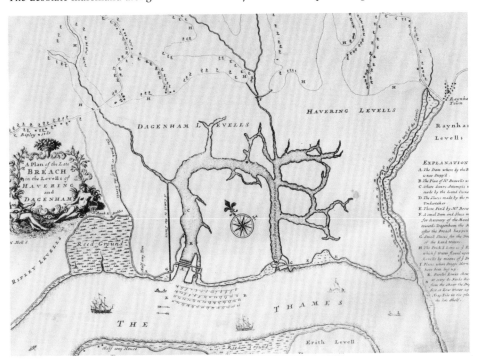

For centuries, flooding had caused problems in the Thames estuary marshland, with perpetual tides damaging sea walls. In 1625, the Dutch engineer Cornelius Vermuyden repaired the breach damage and received a grant of Dagenham marshland. Mudbanks threatened vessels sailing up the estuary to the London docks. Despite frequent repairs, in 1707 an exceptionally high tide demolished 14 feet of seawall at the mouth of the Goresbrook in Dagenham. Repair work proved insufficient to halt the flood, which spread half a mile inland. This later breach in the seawall became known as the Dagenham Gulf.

Chapter Two

Building Becontree

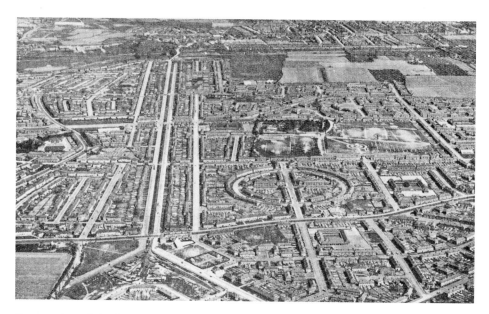

Construction of the Becontree Cottage Estate began in the aftermath of the First World War. The government's plan for slum clearance in London's East End coincided with the urgent need for their 'Homes for Heroes' plan, which began in 1919. The London County Council architects began planning the Becontree Cottage estate.

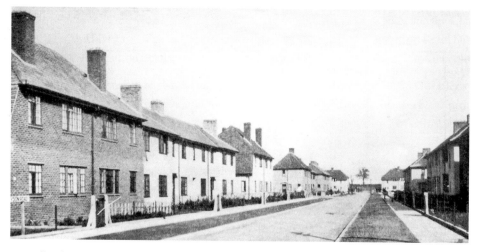

Basically, the estate comprised two-storey buildings, arranged in groups of four or six, with medium or low-pitched roofs, set among gardens, trees, privet hedges and grass verges. They were often laid out in cul-de-sacs (known as banjos) due to their shape.

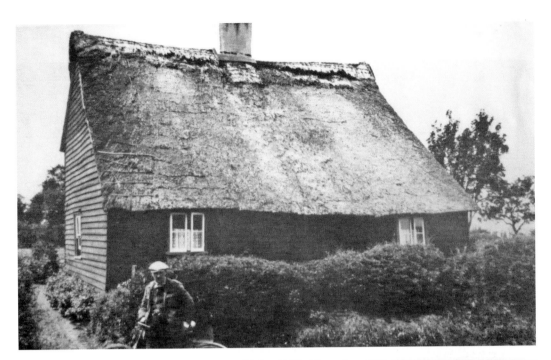

Above: The LCC blueprint, drawn up by the chief architect, George Topham Forrest, included the building of 29,000 new dwellings to accommodate 145,000 people, mainly from East London. From 1920 until 1935, work continued, and when finalised, the Becontree project was regarded as the largest council estate in the world. A thatched and weather-boarded cottage at Becontree Heath (*c.* 1920), demolished to make way for modern housing, can be seen above.

Right: The Rt Hon. Stanley Baldwin (1867–1947), earlier Prime Minister, was involved with this revolutionary piece of town planning and wrote an introduction to the report for the Pilgrim Trust by Terence Young, which outlined in fine detail every aspect of the work involved.

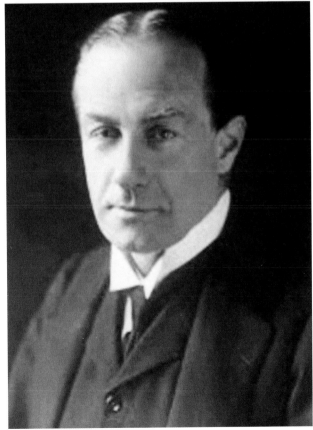

VALENCE HOUSE
a place of discovery

Archives and Local Studies Centre

Origins of
Becontree Estate
street names

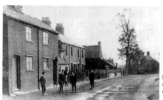

Part 3
The south-east
section of the
estate

Broad Street c1905
ref SB1876
©LBBD Borough Archives

£1.00

Left: As building of Becontree estate took place, it became necessary to name the streets, shopping areas, public buildings and schools. Studying historical annals and maps;,council officials consulted local historians for information about ancient manor houses and farms in order to add provenance to the hundreds of streets that had to be named. Valence House Local Studies Centre have a full range of booklets outlining the origins of Becontree street names.

Below: The land agent employed by London County Council during the early 1920s,was Captain H. W. Amies. On his arrival in Dagenham, he lived at Gale Street Farm. He came to know the local folk and became a Dagenham parish counsellor. His day was long and busy and caused consternation to his young son, Edwin Hardy. The boy attended the grammar school at Brentwood and, when interviewed, remembered the bicycle ride to Chadwell Heath station to catch his school train. In later life, he became a world renowned fashion designer, making clothes for Queen Elizabeth.

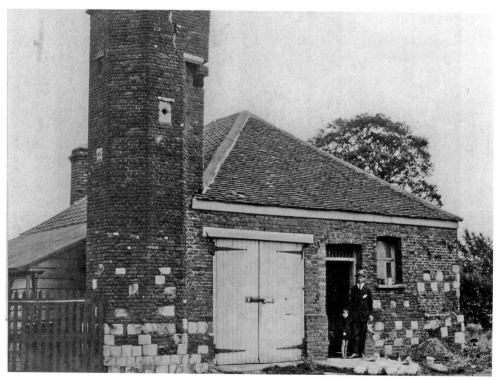

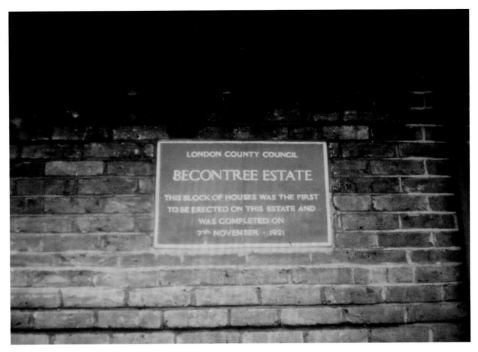

LONDON COUNTY COUNCIL

BECONTREE ESTATE

THIS BLOCK OF HOUSES WAS THE FIRST
TO BE ERECTED ON THIS ESTATE AND
WAS COMPLETED ON
7th NOVEMBER · 1921

Development of the estate began in 1921. The first sections completed were not far from Chadwell Heath station. Building continued speedily. The first homes were in Chitty's Lane, and a plaque to this effect can be seen above. One roofer remembered how a red flag was raised on the chimney of a newly completed house.

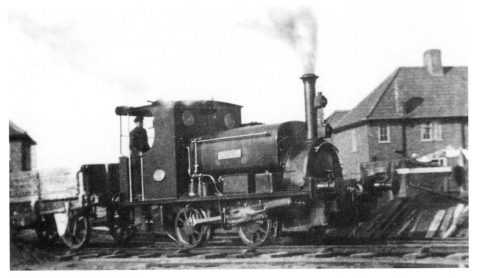

Many Londoners who first came to Dagenham were surprised by the silence of the Dagenham countryside, so different from the noise and bustle of their homes in London's East End. However, those living near the railway station fared better than those where no roads, shops or churches had yet been built. One sound that did enthral youngsters was the small constructor's engine that ran on the slim rails down the centre of Valence Avenue. This today is a wide, grassy track. The engine was affectionately known as the 'Coffee Pot'.

Naked Knees and Blakey'd Boots

Reminiscences of a Dagenham Urchin

Brian Lynch

Left: Journalist and author Brian Lynch remembers his childhood in Becontree Avenue, where he loved the shrubbery opposite his home. This provided a jungle where he and friends played. 'Those visionary architects also included trees in the streets, even little "copses" on street corners, and we had the parks, Goodmayes, Valence, Parsloes ... And in Becontree Avenue we were even luckier because we had "the bushes".'

Below: Small shopping parades began to appear on the estate. Many remember individual butchers, bakers, fish shops, hairdressers – one for every possible commodity. Becontree Avenue shops can be seen below.

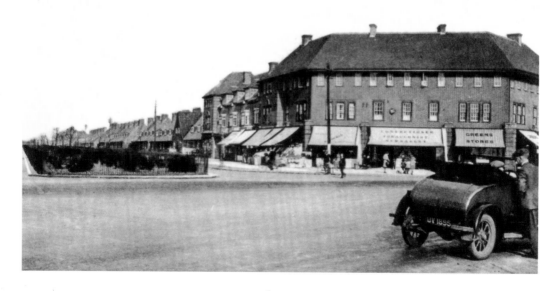

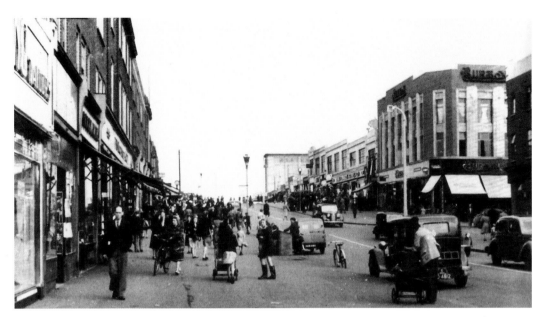

In 1932, Heathway station opened and shops quickly came to the area. This favourite postcard shows the Heathway cinema (later renamed the Gaumont), F. W. Woolworth on the left-hand side and Burtons the Tailors (*above right*), which was the Doughty School of Dancing, alongside Blackbourne Road and the post office.

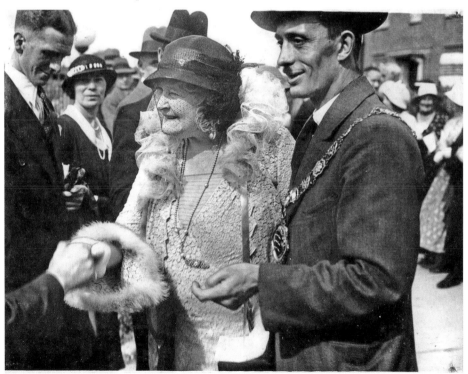

Libraries made their appearance in the 1930s around Dagenham. In 1934, Daisy, Countess of Warwick, once King Edward VII's favourite mistress, came to Dagenham to open the Rectory Library.

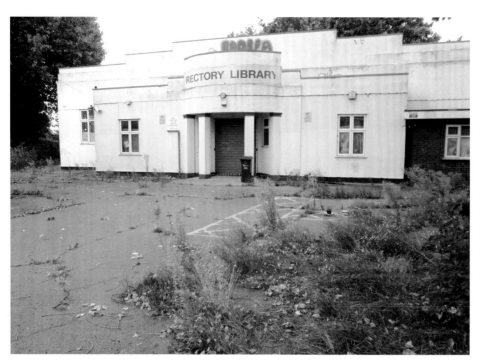

Rectory Library today, now uninhabited and forlorn, but still standing.

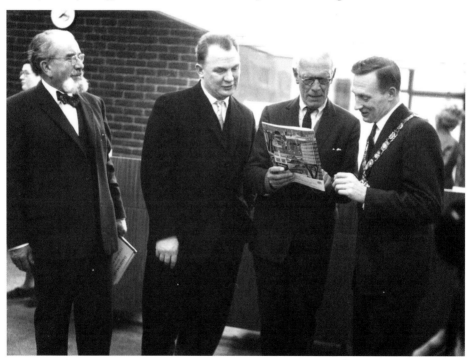

The opening of Fanshawe Library in the early 1960s was a crowd-pulling event, bringing together John O'Leary (then the Head of Essex Libraries), Cllr David Dodd, Sir Malcolm Muggeridge and Mayor Cllr Jack Thomas.

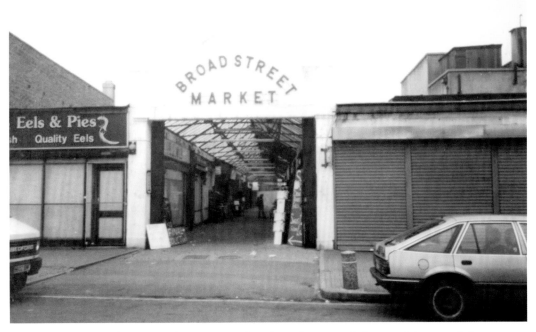

The indoor market at Broad Street arrived in the early 1920s. Before receiving a roof, it was merely a group of sheds selling vegetables and flowers, with itinerant stall holders arriving weekly. For over seventy years it flourished alongside the Grays Co-operative Store, but that too was demolished when its time came.

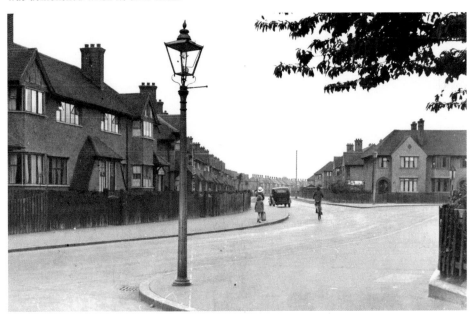

When street lighting came to Dagenham, the municipal gas lamps at Broadstreet/White Barn Lane, where French's farm once stood, provided light, but also fun for local children, who used them to tie skipping ropes. This iron gas lamp reminds us how they looked before they were replaced in the early 1950s by modern concrete pillars.

Chapter Three

Barking Abbey

Left: For almost 900 years, the people of Barking respected their abbey, which had been built 'in a cramped area of land between the Roding and the Back river, a narrow place liable to floods'. The chronicler the Venerable Bede (AD 673–735) recorded in his *History of the English Church and People* that the Bishop Erkenwald had founded two famous monasteries, one at Barking (Berecingum) for his sister Ethelburga and another at Chertsey (Ceortesei) by the River Thames.

Below: Erkenwald accomplished this work in AD 666 and his sister Ethelburga became the first abbess. He was subsequently selected to be the 4th Bishop of London. Dedicated to St Mary, the Benedictine Abbey became one of the richest and most important in England under the reign of Sebbi, then king of the East Saxons (673–735). (*photograph courtesy of 1931 Barking Historical Paegeant, 1931*)

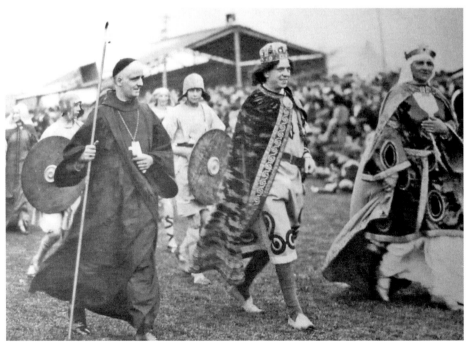

Above: Having flourished for 200 years, around AD 870 Barking Abbey was attacked and laid waste by marauders in the Danish conquest. What happened to the inhabitants is open to conjecture. Certainly, the sister foundation at Chertsey was destroyed. All that remains of the first Barking Abbey is a fragment from a broken Saxon cross found built into the churchyard wall. (*Image courtesy of 1931 Barking Pageant*)

Right: Little is recorded of the history of the abbey from the Danish attacks until the time of William the Conqueror. In 1066, King William I was crowned in Westminster Abbey on Christmas Day. Following his coronation, he moved into Barking Abbey while building work was carried out at the Tower of London. (*Image courtesy of 1931 Barking Pageant*)

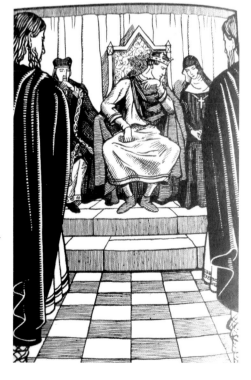

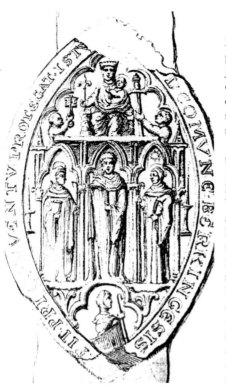

Medieval Barking was dominated by the powerful, rich abbey. Until the reign of King John, the abbess was chosen by the king. Later on, the abbess was elected by the nuns in the chapter. When appointed, she lived in grand state, taking precedence as a baron. In the abbey, she reigned supreme and supervised a huge staff.

The outstanding event in local history in Tudor times was the dissolution of Barking Abbey in 1539. Henry VIII sent visitors to all religious houses in England to report on their condition. When he visited Barking, £4 (an enormous amount) was paid to the King's visitors. Some historians have felt this was possibly a bribe to produce a good report, but closure was inevitable. Dorothy Barley, then the last abbess, surrendered the abbey to Dr William Petre on 14 November 1539. The nuns were pensioned off and sent home. The eighteenth-century drawing (*left*) of the seal of Barking Abbey (1539) shows St Erkenwald standing between St Ethelburga and St Hildelitha. Above sits the Virgin and Child and an abbess, below. Dr William Petre can be seen in the picture below.

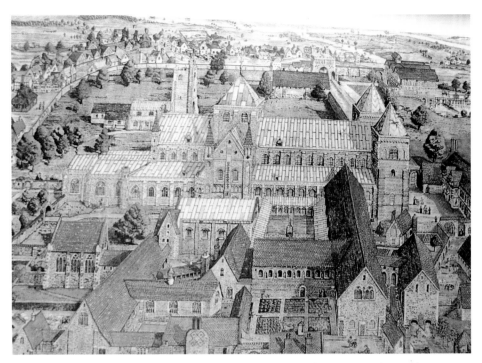

Here is a reconstruction by A. C. Rolfe of how the abbey may have appeared around 1500.

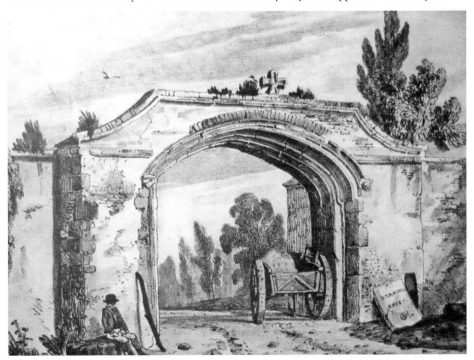

From records, it is believed that there were three gates to Barking Abbey. The Great Gate was probably near the town quay, where the abbess had 'two paier of staires'. This drawing by George Harley shows the gateway to the precinct 350 feet north of the Curfew Tower. This was demolished in 1885.

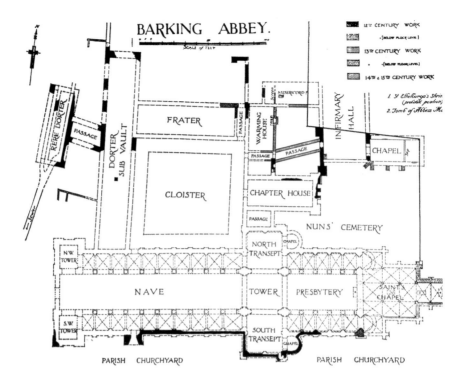

Plan of Barking Abbey adapted from drawing by Albert Clapham in 1911.

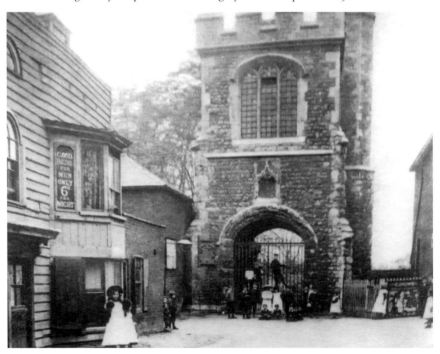

The Curfew Tower, sometimes called the Firebell Gate, *c.* 1900, leading to St Margaret's church.

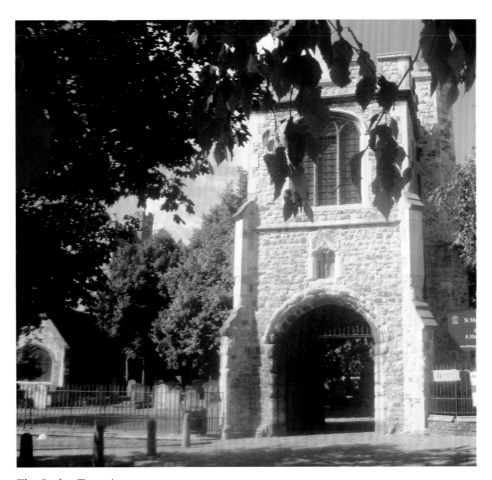

The Curfew Tower in 2009.

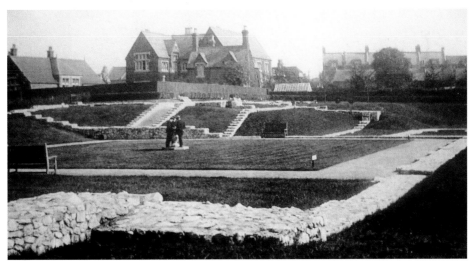

Layout after the extensive archaeological work carried out in 1911. Other work of this kind was carried out over further decades.

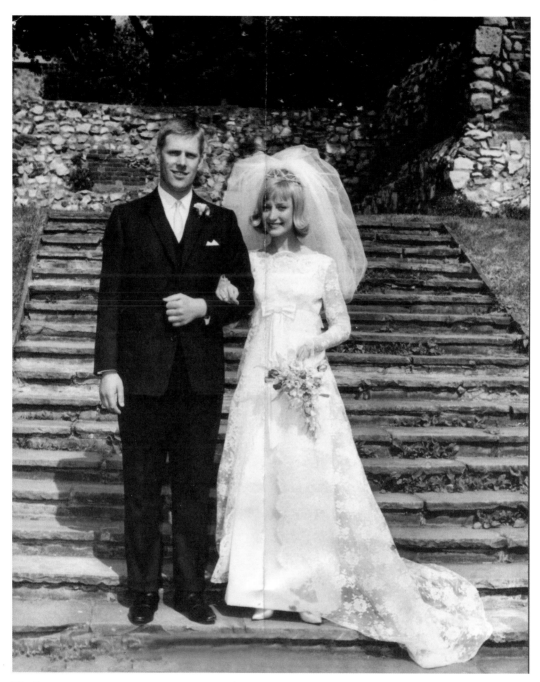

The famous circumnavigator, Capt. James Cook, and Elizabeth Batts, probably the most famous couple to have been married within the precincts of the abbey at St Margaret's church in December 1762, set a pattern for many future bridal couples. Over the last century, local photographers have chosen the abbey ruins as an interesting historical backdrop for the bride and groom, *c.* 1966.

Chapter Four

Barking's Expanding Community

While Dagenham in centuries past was but a small farming area, its neighbour, Barking, had an important place on ancient maps due to its famous abbey dating from AD 666. From the Middle Ages, Barking was also famous as a fishing port, sending its produce to London's Billingsgate Market.

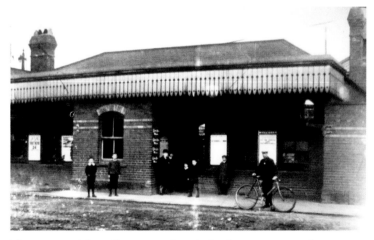

The coming of the railway to Barking had a huge impact on the town. In 1854, Barking station opened when the terminus was located at Tilbury. Two years later, the route was extended to Southend. Barking station was rebuilt in 1889, and in 1902, the Underground District Line was extended. Within three years, it was electrified. Continuing development ensued, with more than 100 houses and shops being demolished to make way for the newly enlarged station, which opened in 1907.

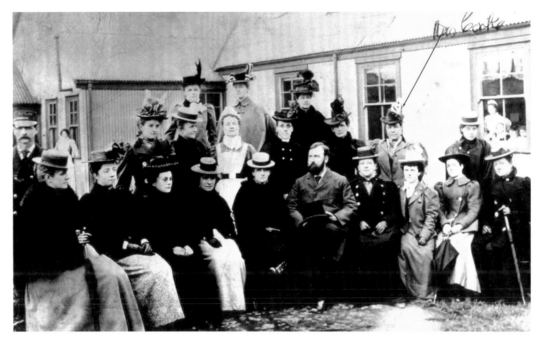

The main hospital began as an infectious diseases hospital on Upney Meadow in 1893, and its administrative block was added ten years later. Extended wings were added over the decades, and Barking Hospital was partly rebuilt and enlarged in 1966. It was opened by HRH Princess Alexandra in April 1967.

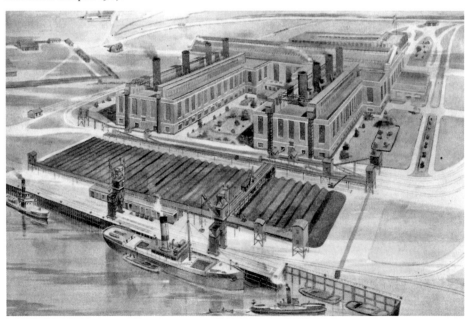

On 19 May 1925, Barking Power Station at Creekmouth was opened by King George V. The general manager of the County of London Company at the time of the opening was Archibald Page (1875–1949), who was later knighted for his work in creating the national grid. The power station brought hundreds of workers to Creekmouth.

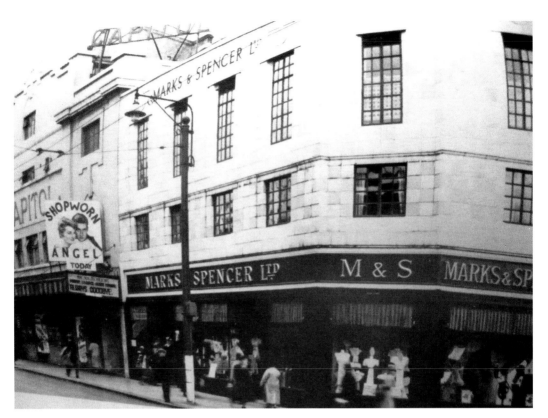

Above: Marks & Spencer in East Street at ground level in 1938. We can also see the very popular Capitol Cinema next door, which had a large clientele.

Right: Winch's Store at Nos 25–31 Ripple Road was a favourite furniture store as it was easily within walking distance of the station for many out of town customers.

WINCH'S

of 25/31 RIPPLE ROAD

for Your Furniture, Carpets, Bedding
Largest Selection in the Borough

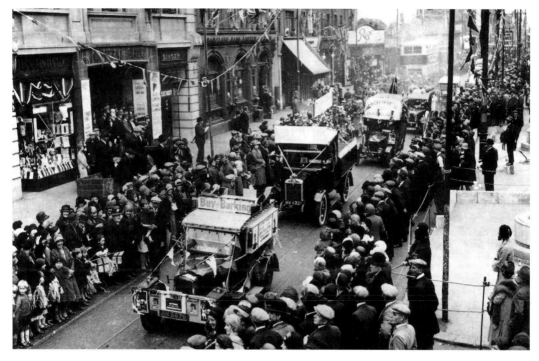

TO THE AUDIENCE.—In these rapidly passing scenes of Ancient Barking, let your minds drift back to the early days when this new Borough was still a little village . . . dream of those days and the great characters who lived in them; of the Kings and Queens who came to this place, of the Saints whose home it was, of the famous men who once were boys roaming in these fields. Then think ahead a hundred years or more, and remember that each one of you, however humble, can in your own short life make your mark upon your generation, and so upon the countless generations of Barking yet to come.

Above: In October 1931, the Barking Charter Pageant took place when the town achieved borough status. It was a municipal milestone. Although this was a time of depression in the country, huge planning and expense went into making the occasion spectacular. The notable Charter Town Clerk, Stephen Arthur Jewers, Frederick Brand, Alexander Glenny, Robert Hewitt and Colonel Lofthus all contributed to the specially commissioned *Book of Barking*.

Left: Frank Lascelles was called upon to be Master of the Barking Pageant and had performed this service for other English towns, including the Pageant of London for King George V's Coronation in 1910. Barking turned out to be a mammoth production, with eleven scenes, each with its own separate organising committee. In all, hundreds took part over the eleven days and thousands came to visit the event.

Right: With the town ever expanding, the notable Glenny family, who were initially market gardeners and farmers, branched into the brewing industry and then into estate agency. Around 1815, William Glenny (1760–1850) took over part of the Bifrons estate, and Edward Glenny (1800–81) built a new Bifrons mansion nearby. The Glennys became distinguished civic leaders.

Below: Much of the Barking transformation took place in the twentieth century. Dozens of companies were set up along the Thames and Roding rivers, manufacturing chemicals and fertilisers, iron and steel products and heavy and light engineering. Sir John V Bennet Lawes founded his chemical works at Creekmouth in 1857.

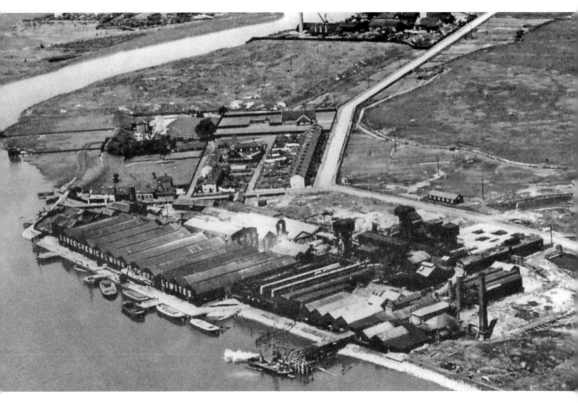

With Monday's cold
 from Sunday's Roast
—with fish and cheese and meat

YOU MUST
HAVE
EPICURE

SWEET

MUSTARD

The Epicure PICKLES
MUSTARD
PICCALILLI
1'9

*to make your
meals complete!*

Epicure
Two delicious varieties, Mustard and Sweet

➤ **Piccalilli**

Ocean Preserving Co. Ltd., Epicure Works, Alfreds Way, Barking

Left: The Ocean Preserving Company, sited in Barking, employed hundreds of local women in their Epicure factory.

Below: With so much industry taking place in Barking, one forgets that for 500 years the town's main business was fishing, supplying the local and London markets. Around 1850, some 220 fishing smacks were crewed by 1,370 men and boys. Fishing boats were built and repaired at Barking until the end of the nineteenth century.

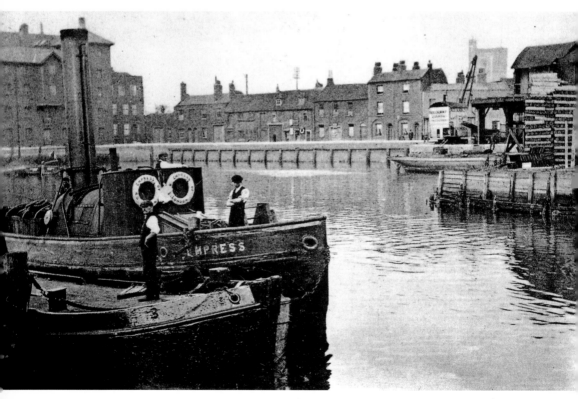

Above: These beautiful frescoes can be seen at Eastbury Manor House, reminding people of the ancient fishing industry that ended in Barking at the end of the nineteenth century.

Right: The Hewett family were foremost in Barking. The year 1760 brought Scrymgeour Hewett, a Scot, to the town, where he met Sarah Whennell, daughter of a Barking smack owner. Hugely successful, he started a dynasty extending his range of Short Blue Fleet using ice to preserve the fish and wooden trunks in place of the old wicker 'peds'. The demise of the fishing industry was caused chiefly by the railways providing rapid transport from East coast ports directly into Billingsgate Market.

Creekmouth is small but fascinating, and was chosen by Frederick Handley Page (1885–1962) in 1908 to set up his aeronautical engineering business. Within a year, with a capital of £10,000, he opened Britain's first aircraft factory at Creekmouth, building his first experimental glider, tested from the top of a Barking dyke. He built a quadroplane and further aeroplanes, not without fatalities. In 1912, Handley Page relocated his operations to Cricklewood.

Chapter Five

Dagenham Village

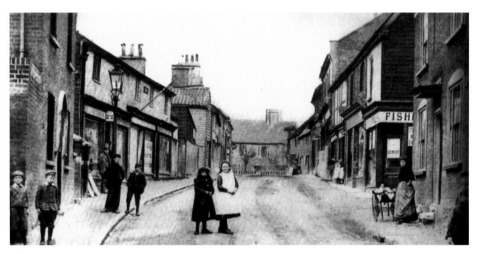

Before the construction of the Becontree estate, the old village at Dagenham was a small community surrounding the ancient parish church of St Peter and St Paul. The main thoroughfare was Crown Street, named after the Rose & Crown Inn at No. 14. This was demolished in 1963.

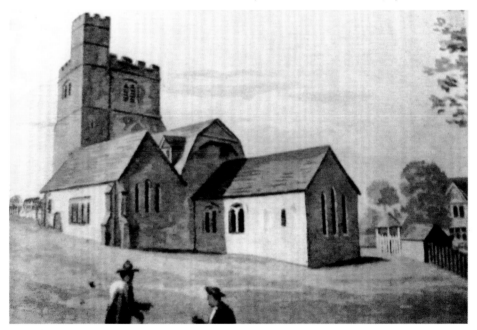

St Peter and St Paul church as it looked around 1770. Built in the late twelfth century, it came under the authority of Barking Abbey. Changes to the structure inevitably took place over the centuries. A south aisle was added in the 1500s.

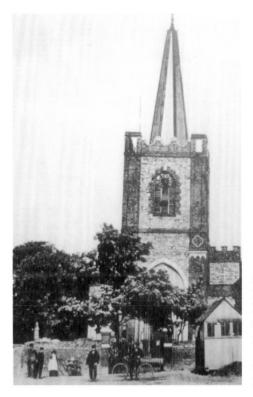

St Peter and St Paul church collapsed in December 1800. Because the minister was late, the congregation had not been able to enter, so no one was hurt. Extensive reparations followed. A spire was added. By 1920, this was in a dilapidated state and had to be removed by Mr West, who was also the local undertaker and builder.

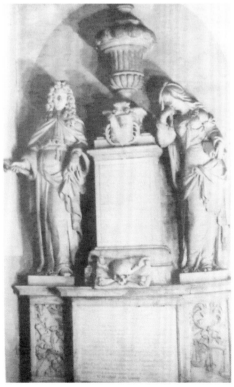

Within the church are many ancient monuments and brasses. This life-size depiction of Sir Richard Alibon and his wife is impressive. He was a judge in 1687, the year he bought land in Dagenham, and was considered a fair and respectable landowner. Alibon Road is named for him.

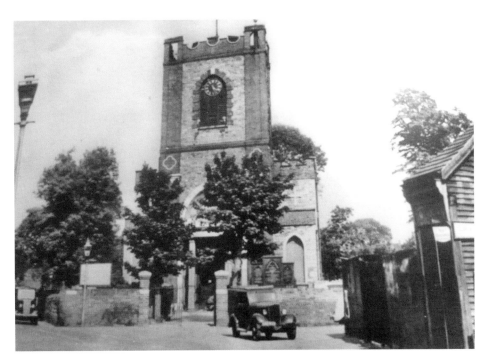

Another view of the parish church in the 1930s.

The Cross Keys, standing opposite the parish church, dates from the fifteenth century and is believed to be the oldest surviving secular building in Dagenham. Previously, it was called The Queen's Head. Fortunately, it escaped the bulldozers, and is believed to have been the home of Sir John Comyns (1667–1740), grandson of a village tanner, who made enough money to build Hylands House in Chelmsford.

The Ford Endowed School had served Dagenham Village well. William Ford, a local farmer, who died in 1825, left £10,000 to found a school for local children. The school was eventually built in 1841. His name is remembered in the district, although the school is no longer on its original site. It moved to Ford Road in 1974.

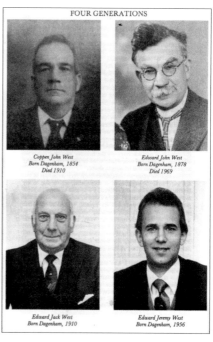

FOUR GENERATIONS

Coppen John West
Born Dagenham, 1854
Died 1910

Edward John West
Born Dagenham, 1878
Died 1969

Edward Jack West
Born Dagenham, 1910

Edward Jeremy West
Born Dagenham, 1956

Up until the 1920s, Dagenham Village consisted mainly of farmland and market gardens. Jack West, the well known funeral director whose family's association with the area went back more than 200 years, wrote a definitive history, *Personal Memories of a Dagenham Village*, which is a wonderful chronicle of this special community and its residents. Jamie West (*left*), fifth generation of the West funeral directors. can be seen above with Jeremy West MBE (*far right*), as well as other earlier, distinguished family members.

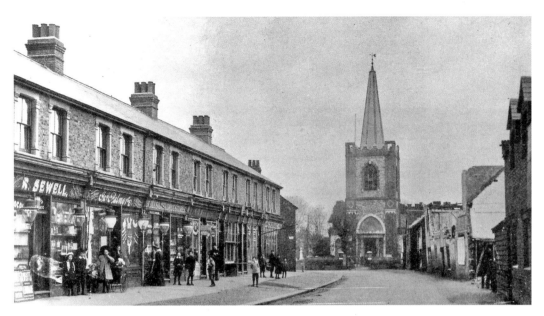

Historians have collected memories from older residents who remembered the shops and their owners over the decades. The late Alfred L. Wakeling, in his book, *The Village That Died*, described aspects of his home in Church Elm Lane, which included school, sport and life during the war. At one time, there were three inns, a vicarage, blacksmith's forge and almshouses, as well as shops serving the villagers.

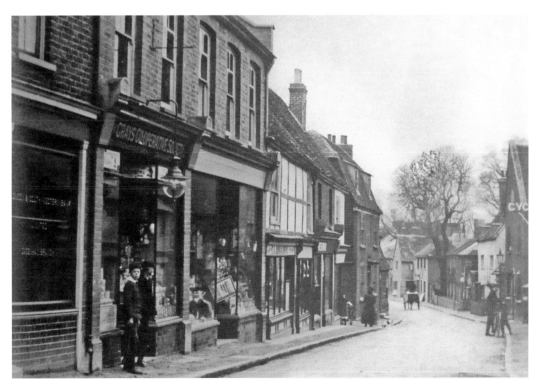

Another view of Crown Street in the village, looking down towards the parish church, *c.* 1905.

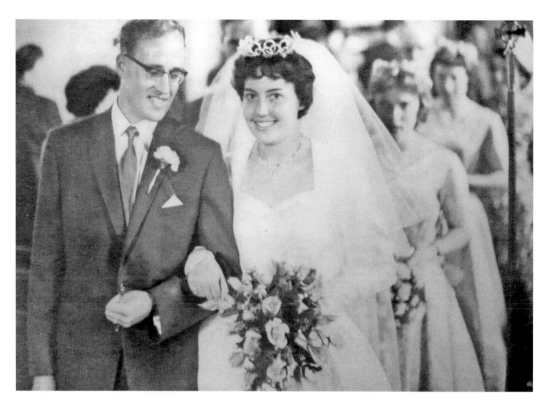

Above: The former Archbishop of Canterbury, George Carey (Baron Carey of Clifton) remembers the arrival of the Revd Edward Porter Conway Patterson, or 'Pit Pat', as the young church members referred to him. Christ-centred and Bible-based, Revd Patterson's great strengths were his directness and simplicity. Dagenham parish church had a full congregation on 25 June 1960 when George and Eileen Carey were married by the Revd Patterson.

Left: Another marriage took place, among so many in 1961, when Carol and Barry Pardue, both of Dagenham, were married at the parish church. Lovely memories were evoked when they returned in 2011 to celebrate their golden wedding anniversary at St Peter and St Paul parish church, Dagenham.

The village contained most of the shops and services required by local residents. Many advertised their services and goods in the local newspaper.

Chapter Six

Ford Motor Company

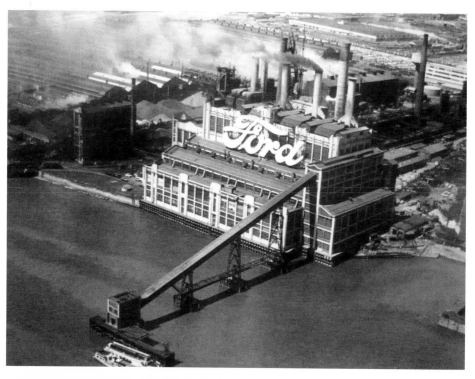

Above: Much of Barking and Dagenham's appearance is linked to industrialisation via the Ford Motor Company. From what was once described as a quiet farming and fishing area, both towns were transformed, in less than a century, into a highly populated industrial area.

Left: Samuel Williams (1824–99), a clever industrialist, started his company in 1855. His work involved unloading cargoes of seagoing vessels into smaller barges called lighters. By 1861, he was the owner of the *Little Eastern*, one of the first of the Thames steam barges. Williams bought riverside land by the Thames and developed Dagenham Dock. He and his successors enlarged the firm to include ship-owning, civil engineering, barge-building and other activities.

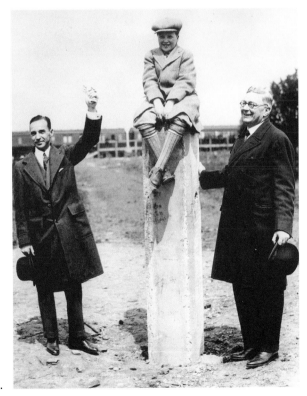

Ford Motor Company's link with
Dagenham is known the world over.
It was ninety years ago, in May 1924,
when the Ford Company completed the
purchase of 244 acres of Dagenham
marshland from Samuel Williams & Co.
at Dagenham Dock. Their plan to build
their gigantic motor plant down by the
Thames eventually became reality. In
1929, Henry Ford's only son, Edsel,
then president of this American firm
from 1919, cut the first turf and the
mighty Ford Company was launched.

Visiting the Ford site in 1929 are Edsel
Ford and Sir Percival Perry. Young
Henry Ford II is sitting on a cement pile.

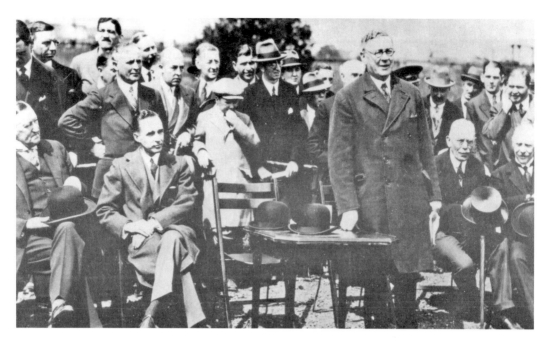

Edsel Ford and Sir Percival Perry outlining the company's plans to the Ford personnel.

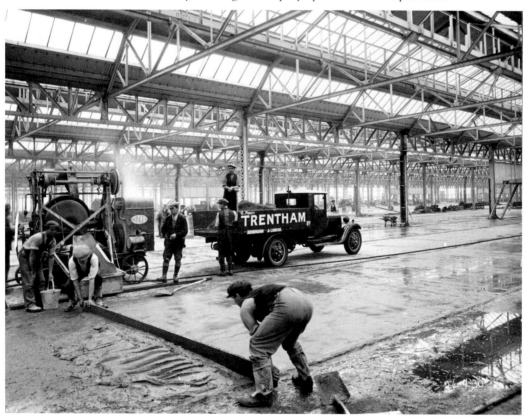

Percy Trentham workers building the Ford Motor plant at Dagenham.

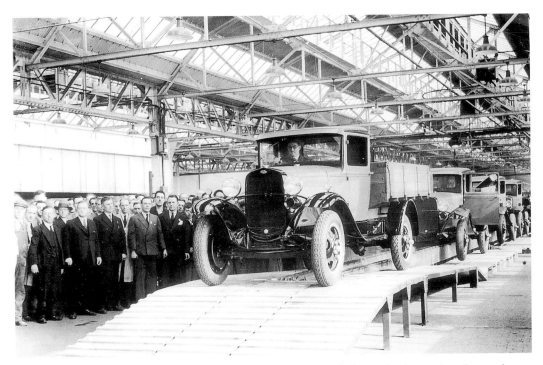

Amazingly, within two years, the Ford Motor factory was ready for production, and workers and management applauded as the first vehicles drove off the assembly line in 1931.

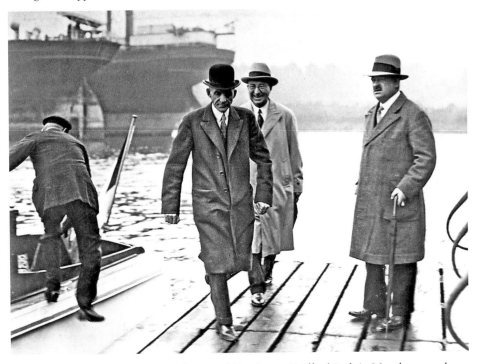

Henry Ford (1863–1947) had already opened his plant at Trafford Park in Manchester and was keen to complete his project. Mr Ford is seen here on a visit to his Dagenham plant.

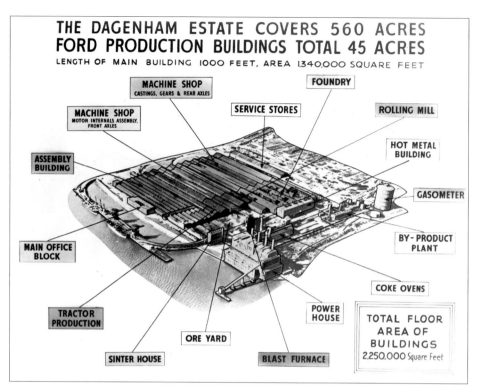

An interesting plan of the Ford production buildings in the plant.

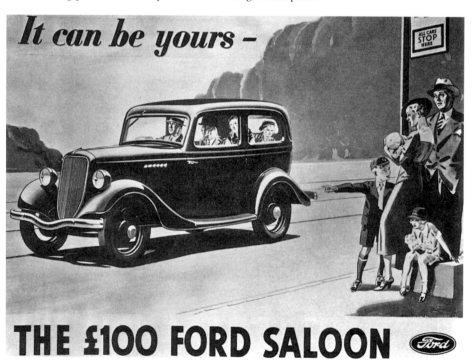

The first £100 car, known as the 'Y' model.

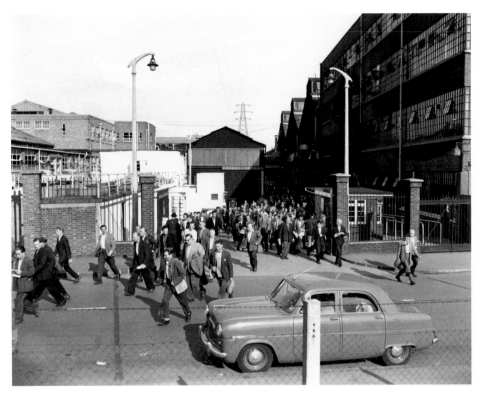

At its height, 55,000 employees provided the workforce at Ford at Dagenham. Here, the workers leave the Chequers Lane factory at Dagenham.

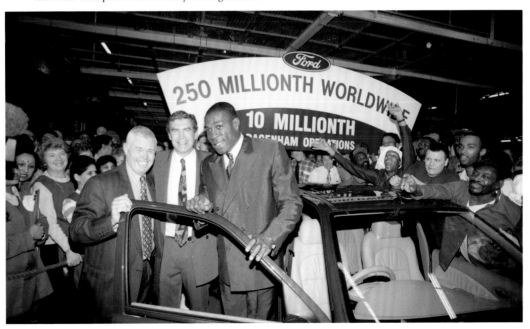

Celebrations for the production of the 250 millionth car worldwide. Sportsmen Sir Trevor Brooking and Frank Bruno lend a hand in celebrating this amazing piece of industrial success.

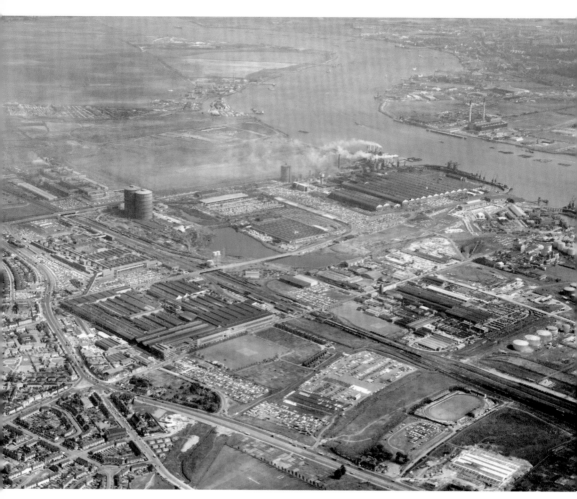

A fascinating aerial view of the River Thames and the Ford Motor Company.

Chapter Seven

Sport and Leisure

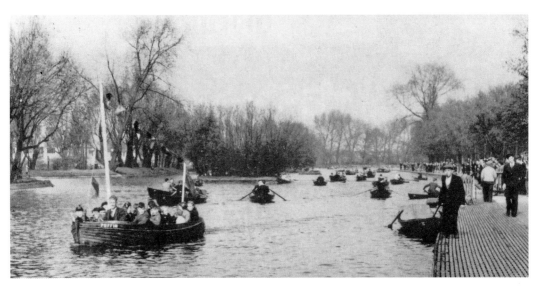

Rest and relaxation are vital for a healthy life. The borough architects realised this way back in Victorian times, and parks and sporting areas were provided for the masses. Barking Park, with its boating lake, was always a favourite with residents from its opening in April 1898. Such fun to hire out a boat as in days gone by, but, unfortunately, this is a thing of the past. In 1931, the open-air swimming pool was built in the park, but closed in later years.

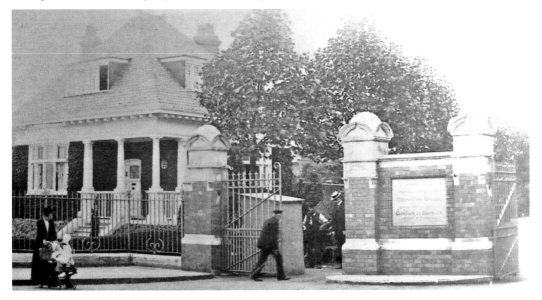

The lodge alongside Barking Park gates was one of the most attractive in the area.

DAGENHAM SWIMMING CLUB

AFFILIATED TO S.C.A.S.A., R.L.S.S., E.C.S. & W.P.A.

President : S. MARINO, Esq.

ANNUAL

GALA

Under A.S.A. Laws

AT

Valence Park Swimming Bath

ON

Thursday, August 12th, 1937

Doors Open to Ticket Holders 7 p.m.
Commence 7.30 p.m.

Hon. Secretary :
W. D. THACKRAY,
57, Philip Avenue,
Rush Green.

Hon. Treasurer :
J. WHITE,
24, Lindisfarne Rd.,
Dagenham.

PROGRAMME PRICE - - - - 2d.

Left: Valence Park was always a popular place and packed out during the summer months.

Below: Leys swimming pool in Ballards Road, Dagenham was another open-air pool that was used during the 1950s. Here, some of the borough's sports people trained. It was a particular favourite of Olympic marathon runner Jim Peters.

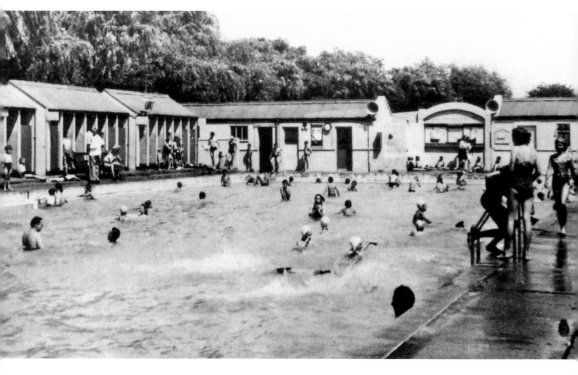

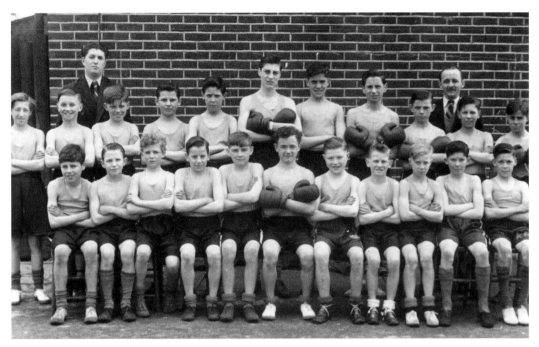

Several young Dagenham boxers were discovered in local school boxing rings, going on to represent not only their school, but their county. From this line-up from Marley School in the 1940s, Paddy O'Callaghan (*front row, fifth from right*) rose to the top of his school and represented both his school and East London.

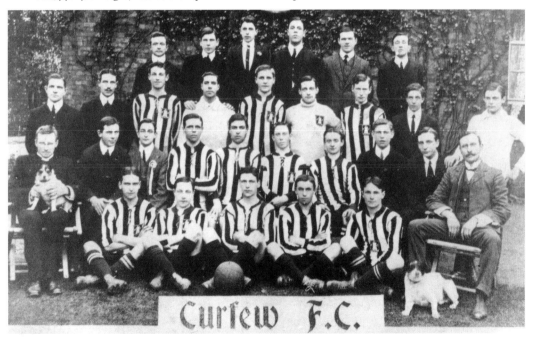

Curfew football team of Barking, shown here in 1910, were the winners of the Manor Division in that season. The vicar of Barking, Revd J. Eisdell, is pictured with the dog sitting on his lap on left of the picture. This club eventually became Barking Town Football Club.

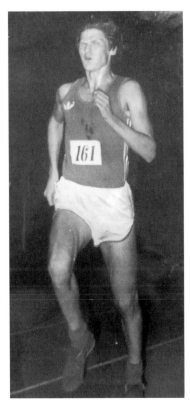

Left: Graeme Fell was a gifted local athlete who attended Dagenham Priory School (former Marley Boys) from 1970–76. During the 1980s, Fell dominated the sport of steeplechase running, and was ranked in the top ten for seven years and the world's top five in 1989. In 1982, he gained silver in the 3,000-metre steeplechase at the Commonwealth Games, and represented Canada at two Olympic Games: Seoul 1988 and Barcelona 1992.

Below: Marley School for Girls in Dagenham were proud of their athletes, particularly the girls' netball team, who played for the county. Elizabeth Wallace (*née* Bray, *centre*) was team captain in 1959.

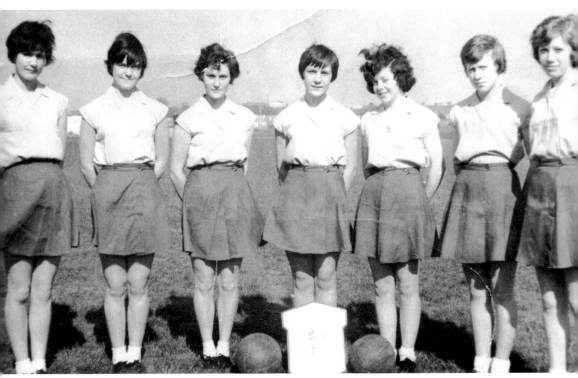

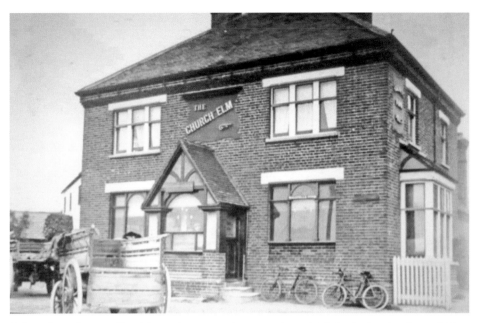

Other places for spending leisure time must, for some, be a drink in the local pub or old inn. There were once dozens of them in Barking, Dagenham and surrounding villages, and most have closed over the last few decades. The Church Elm, with its prime position at the corner of Heathway and the lane that bears its name (deriving from the ancient Cherchehelme in 1456) is just one of many. The large new Dagenham Library has been built on the site.

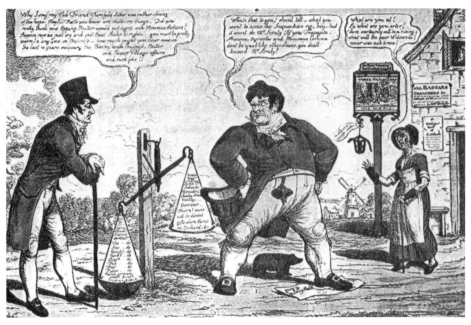

The Three Travellers at Becontree Heath is still a popular pub, just as it was 200 years ago. This cartoon shows 'Big Ben of Bentry Heath' outside the Three Travellers in 1820. The image was published by a Romford bookseller who had a grievance against a local lawyer. The venue is so popular these days that it has won the Best Dagenham Pub of the Year 2014.

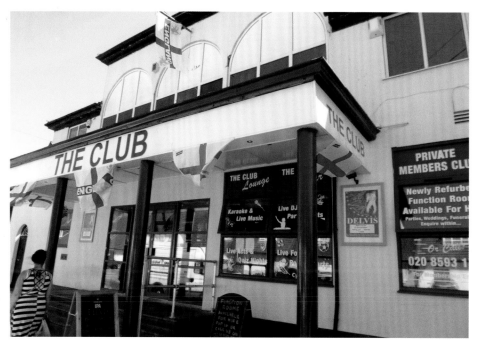

In 1926, when the Becontree estate was being built, the LCC planners allowed a license to the Dagenham Working Men's Club at No. 121 Broad Street. This licensed club has weathered many storms over its ninety years, but always retained its friendly atmosphere. It is now a private members' club.

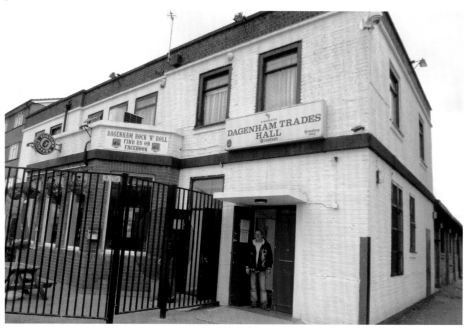

The Dagenham Trades Hall in Charlotte Road, old Dagenham, opened in the 1920s and also provides music in their function room for their members, with entertainment in social surroundings. It has been a well-known venue for snooker, darts, boxing and other pastimes.

The age of the silver screen produced many cinemas in the borough. Barking enjoyed the luxury of at least six cinemas, including the Electric Theatre in Ripple Road, Central Hall, the Rio in Longbridge Road and the Theatre DeLuxe in Bamford Road. Residents obviously enjoyed visiting the Broadway Bioscope Theatre, which seated almost 700 patrons. Built in 1914, some older residents recall seeing a full programme. It became the Broadway Cinema in 1940 and was demolished after the Second World War.

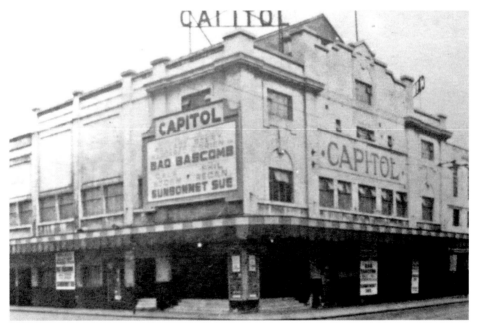

The Capitol in East Street opened on 21 October 1929 and was owned by Mr W. Lesadd. Another large auditorium seated 1,266, where people also enjoyed a full variety programme. It was taken over by ABC Capitol in 1930, but closed on 12 December 1959, having been purchased by Marks & Spencer.

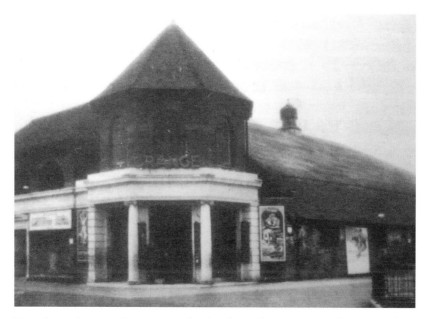

Dagenham also was fortunate in having four cinemas on its doorstep. These included the Mayfair at Whalebone Lane South and the Grange at Goresbrook Road, opened under Kay's Management in the 1920s, seating 1,200 patrons. It was leased to Odeon Theatres and retained its name. It closed in 1963.

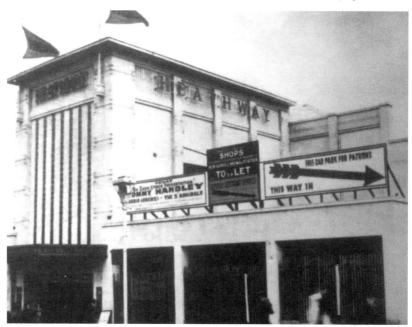

Dagenham Heathway's famous cinema, built by architect George Coles, was probably the largest, seating 2,200 people. Opening in 1936, it changed its name to the Gaumont in 1950 and the Odeon in 1964. It closed its doors in February 1971 and was converted into a DIY store. It was demolished, and is now part of a new shopping complex.

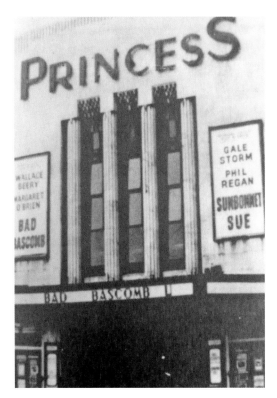

Right: The 'super' Princess Cinema at New Road, Dagenham, opened on 8 October 1932. It was designed by Robert Cromie and could seat almost 2,000 patrons. It had the most magnificent Compton organ, orchestra and a café. Variety performances took place on stage as well as films, and the owner, Mr Lou Morris, was taken over by ABC on 28 August 1933. This cinema closed in 1960, bound for conversion into a ten-pin bowling alley, which ended its life as the 'Superbowl'.

Below: The Chequers Inn on the New Road was not just an ancient inn. In more modern times, it was well known for its food and entertainment. In the 1920s, when the Ford Motor Company was being constructed in the vicinity, it was a boarding house. It lends its name to Chequers Lane.

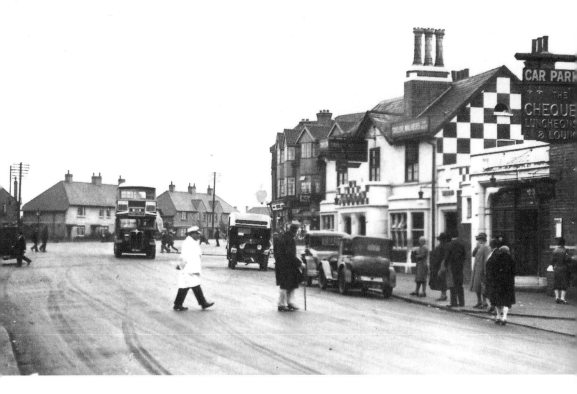

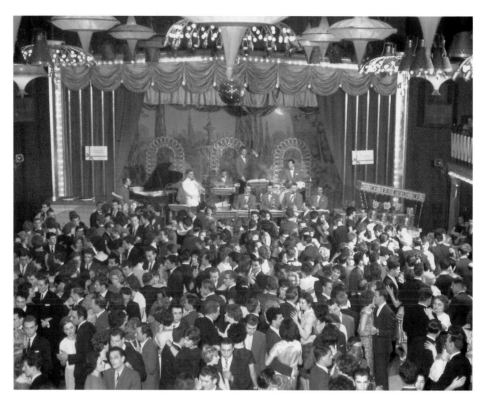

Of course sport and leisure are enjoyable, but so is dancing, and other than Saturday night hops in the youth club, there were not many places to dance to a top live band during the 1960s. But then the Ilford Palais arrived and the young people of Barking and Dagenham flocked to what was considered to be a state-of-the-art dance hall. Unfortunately, it has the dubious notoriety of hiring a new manager by the name of now disgraced Jimmy Savile, who introduced twin-deck *Top of the Pops*-style records in those rock 'n' roll years.

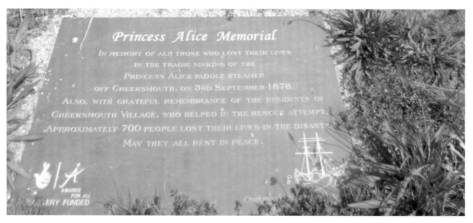

A leisurely trip down the river was a treat back in Victorian times. However, one outing in September 1878 ended in disaster. The *Princess Alice*, a pleasure steamer, was returning from Gravesend and arrived at Creekmouth when it was rammed by the *Bywell Castle*, an iron collier. More than 650 people drowned within minutes in the raw sewage water. Their bodies were brought to the little mission hall at Creekmouth. A plaque near the riverside reminds us of this terrible tragedy.

Chapter Eight

The War Years

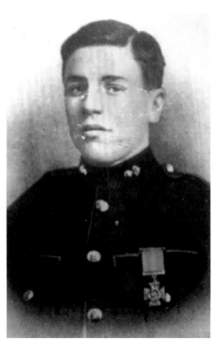

Essex has been at the centre of conflict since the earliest days of recorded history. There are dozens of local war heroes who died in past world wars whom we see commemorated on the war memorials and in street names. Laurence Calvert VC MM (1956) is remembered in Calvert Close, and Job Drain VC (1895–1975) of the Royal Field Artillery was awarded the Victoria Cross during the First World War. His statue stands outside the Broadway Theatre, Barking.

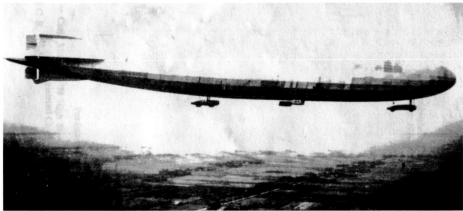

The tragedy of the First World War is well documented, and individuals within the borough have recorded their memories, which are lodged at the Valence House Museum. One local resident's uncle witnessed seeing a Zeppelin in flames in September 1916. Eventually, he learned that it had been the Naval Zeppelin airship L32, which was shot down by 2nd Lt Sowrey from Suttons Farm aerodrome in Hornchurch. Hovering in flames over Billericay, it eventually came down in Farmer Maryon's field. All twenty-two crew perished and were buried at Great Burstead church. They were later removed to the German Military Cemetery in Cannock.

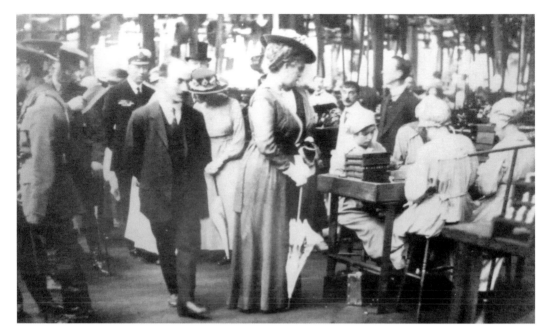

The Sterling Factory, which opened in Dagenham in 1910, was originally called the Berliner Telephone Factory, but changed its name in 1913 due to the increasing anti-German feelings in Britain. The firm switched their projects from electrical and telephone equipment to war work.

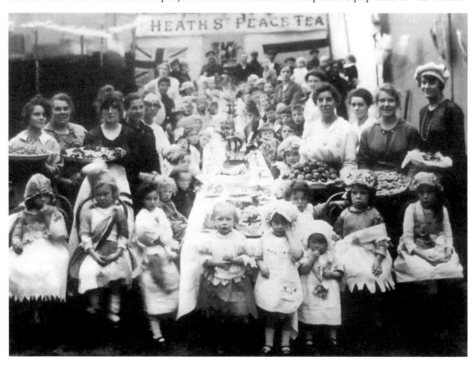

Such was the huge relief of the British people when the Armistice was signed on 11 November 1918. Rationing had meant meagre food allowances for four years, but somehow, women managed to gather enough provisions to create this celebration party at Heath Street, Barking.

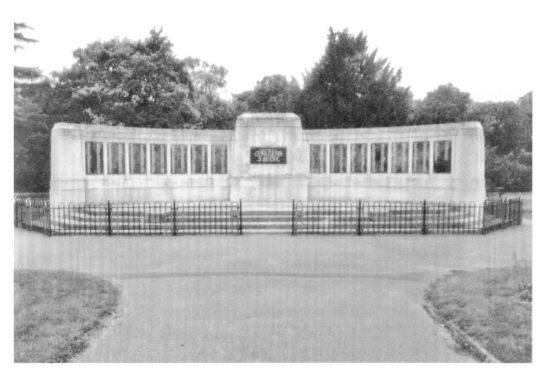

Above: The war dead are recorded on numerous war memorials in the borough, including the more recently built memorial at Dagenham's old village. Rippleside Cemetery, laid out by Barking Parish Burial Board, opened in 1884, and it is here that we find another war memorial dedicated to those who lost their lives in the First World War. Barking's main war memorial, unveiled in the park in 1922, bore the names of more than 800 fallen.

Right: At 11.00 a.m. on Sunday 3 September 1939, the declaration of war was broadcast on the BBC, and shortly after, the first air raid siren was heard throughout the borough. Once again, rationing was introduced in order to ensure fair feeding throughout the nation.

A meaty subject...

She needs as
much meat as
he does!

Do heavy workers need more meat?
No. Daily wear and tear on the tissues is not materially affected by the

Above: Anderson air raid shelters were the order of the day, and these were delivered to householders to be erected in the back garden.

Left: With compulsory food rationing, people had to register with local shops, and an authorised listing was available. Although ration book coupons could be awkward, it was felt this was the fairest way of feeding so many people in such difficult times.

YOUR BLACK-OUT

Test your black-out room by room. When it is really dark, view your windows from the bottom of the garden or the other side of the street.

There is no excuse for bad black-out. In halls, passages, and on landings where bright, white light is not essential, use blue or other tinted lamps of low wattage. A bedside light to undress by need be little more than a glimmer. In your living rooms, however, have the same light as in peace time. Plenty of light makes for cheerfulness.

Here are some things you can do to improve the black-out in any room where it is not yet perfect :

(1) Shade your lights so that the light is not on the windows.
(2) Line existing curtains with suitable material.
(3) Provide a blind to cover the whole of the window space, with, if possible, six inches overlap on either side and at the bottom.
(4) Tack curtains at the side, so that they do not creep along and let the light in.
(5) Provide the inner edges of the curtains with small safety pins, so that when drawn they can be fastened and prevent gaping.
(6) Across a bay window, fix draw curtains of suitable material, so that the bay is cut off from the rest of the room after black-out. The bay windows must, of course, have their ordinary curtains drawn. If properly carried out, this provides a perfect black-out.
(7) Cut strips of black-out paper 5-6 inches wide, and paste firmly down the sides and top and bottom of windows where light filters through.

Properly planned and made black-out arrangements do *not* interfere with ventilation.

Right: The government published posters alerting people to put up 'blackout curtains'.

Below: Evacuation started almost immediately in 1939. It was estimated that in Dagenham, more than 17,000 registered for evacuation, mainly mothers with small children, and around double that figure in Barking during the first month of the war. Barking Abbey School suffered bomb damage and its pupils were sent to Weston-super-Mare, while pupils at other Barking schools were despatched to other more peaceful areas in Britain. By August 1940, local people sadly realised that this area, located near a dense concentration of industrial premises, so close to the capital, was increasingly becoming the target for German bombs. Evacuees at Yarmouth at the start of the Second World War are shown below.

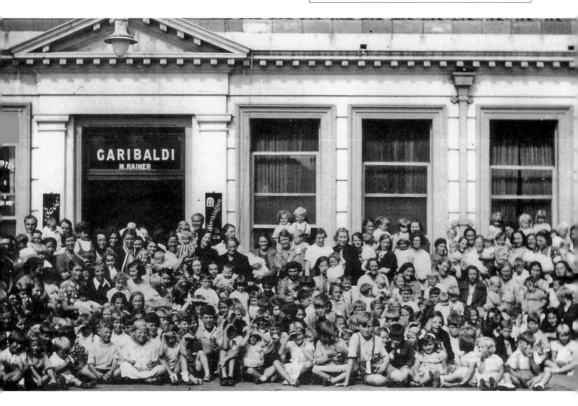

Creekmouth was always a lonely spot alongside the Thames with just one pub, the Crooked Billet. In the first year of the war, some Air Force personnel moved to Creekmouth to winch up barrage balloons and joined the local fishermen for a drink or two.

Barrage balloons at Creekmouth, 1939.

Above: Those not on active service joined the Home Guard, as well as carrying on with their ordinary work duties. An Air Raid Precaution unit occupied Eastbury House and another based at Eastbury school.

Right: The first air raids to affect the borough, particularly in the Barking area, took place between June and August 1940. The Battle of Britain followed in August, with the devastating London Blitz thereafter, until the end of May 1941, with Baedeker raids using incendiary bombs. Later in the war, both Barking and Dagenham suffered when V1 (Doodlebug) flying bombs caused destruction to people and property. This continued until the end of the war in 1945. Here we see the civic centre in Dagenham protected by sandbags.

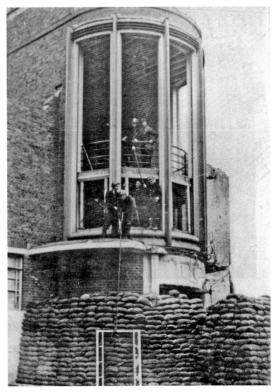

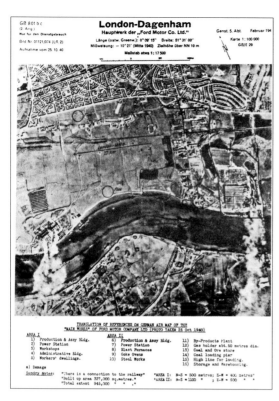

Left: With Dagenham being so close to the Ford Motor Company, bombing was inevitably tragic. John O'Leary's *Danger Over Dagenham* names every single street that was targeted, and lists those families who lost their lives or were injured. This German aerial photograph gives an uncomfortable view of their target sites.

Below: With the end of the war almost in sight, in January 1945, members of the Ford Motor Company arranged a party for some of their workers' children. (*Photograph courtesy of the Ford Motor Company*)

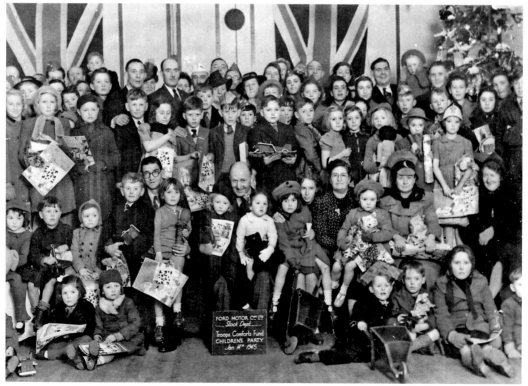

Chapter Nine
Centres of Worship and Learning

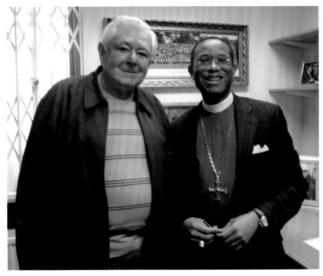

The history of the abbey at Barking is covered in Chapter Three. An important place of worship in the borough is Barking's St Margaret's parish church. Originally built within the abbey precincts, it is believed to have functioned as a chapel before being made into a parish church around 1300. Former Mayor of Barking Pat Manley is pictured here with the Rector of St Margaret's church, the Rt Revd Dr Trevor Mwamba, former Bishop of Botswana.

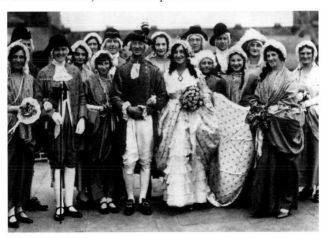

Numerous eminent people are recorded in the marriage register at St Margaret's church. One notable name was the distinguished sailor and circumnavigator Capt. James Cook, who married Elizabeth Batts, a local girl, by private licence, on 21 December 1762. (*Courtesy of the 1931 Barking Pageant*)

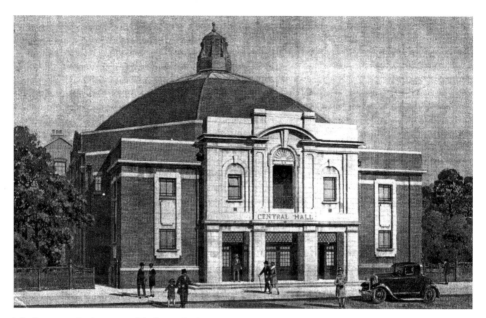

The huge Methodist central hall was built in 1930 in Heathway, Dagenham, to carry on work begun in the small tin chapel that had served the area well for five years. Every form of church life took place there, but it later became derelict and was replaced in 1974 by the Salvation of God C & S church.

From the seventeenth century onward, Nonconformity existed in the area. In 1658, the Barking Meeting of the Society of Friends, popularly known as the Quakers, was formed. Small congregations met in the homes of members. By 1766, the Quakers formed the largest group of religious dissenters active in Barking. When this building was demolished, a new church was constructed, which still survives.

Barking Methodist Church

A Brief History of the Church
from 1791

Price 2/6

Right: Methodism came to Barking by way of preachers in the late eighteenth century. John Wesley spoke to gatherings during 1783 in the open air. A wooden hall served the Methodists until a chapel was built in East Street. This was demolished after the larger central hall was built in 1928.

Below: Other churches were built in the area for Roman Catholics, Congregationalists, Baptists, Wesleyans, Plymouth Brethren, Peculiar People and, over the last fifty years, other denominations including places of worship for Elims, Pentecostals, a Synagogue and a Gospel church. The Gurdwara Singh Sabha, London East, attracts many worshippers at their North Street, Barking centre.

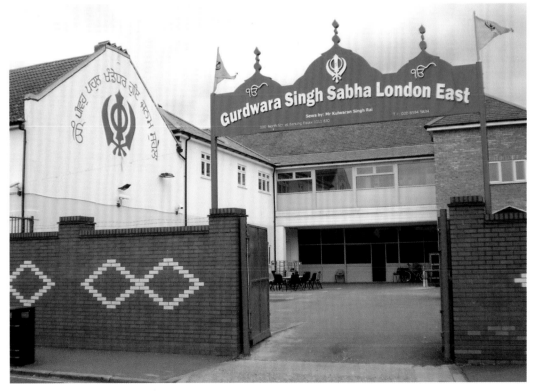

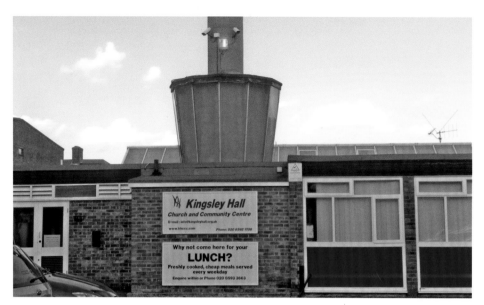

Kingsley Hall church and community centre in Dagenham has long been a place of warmth and worship. From 1929, when it was originally envisaged by Doris and Muriel Lester, it has grown in strength and local popularity. The Lesters provided the first nursery school education in the Becontree Estate, and Kingsley Hall continues to be a centre for various clubs where Christian principles are practised. Among many visitors over the years, Mahatma Ghandi paid a visit in 1930, writing later of 'being surrounded by love' at Kingsley Hall.

Roman Catholic recusants were recorded in Barking in the sixteenth and seventeenth centuries, and St Mary and St Ethelburga was built in 1869 to replace a temporary church opened in 1858 and later rebuilt in 1979. The late Cardinal Heenan was curate there in 1931–37 and the Roman Catholics were the first religious body to work on the new Becontree estate.

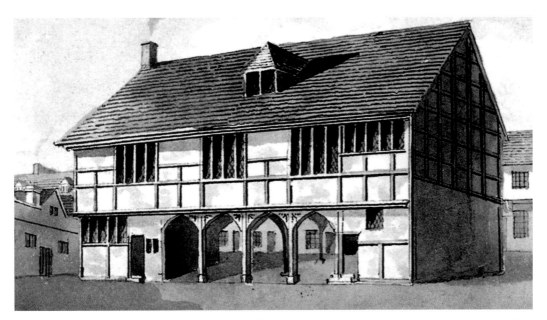

In seventeenth- and eighteenth-century Barking, the centre of the town was the market place. Here stood the market hall, which was built in 1567/68. This is the earliest reference to formal education in Barking, as the attic became a schoolroom. In 1642, Sir James Cambell of Clayhall bequeathed funds to build a free school in the town. Various private schools and church schools were opened during the eighteenth and nineteenth centuries. It wasn't until the 1870 Education Act, when elementary education became compulsory, that Barking and Dagenham saw dozens of schools constructed for the increasing population. The market hall was demolished in 1923.

Ford Endowed Free School opened in Dagenham Village in 1841, and served the community for 130 years until it moved to Ford Road. Of the five original Board Schools in Dagenham existing around the turn of the twentieth century, only Marsh Green Primary still stands (*pictured*). Built in 1902, with its frontage facing New Road (A13), its distinctive bell tower has long gone, but its later 1928 structure in South Close will be familiar to former pupils who attended in earlier years.

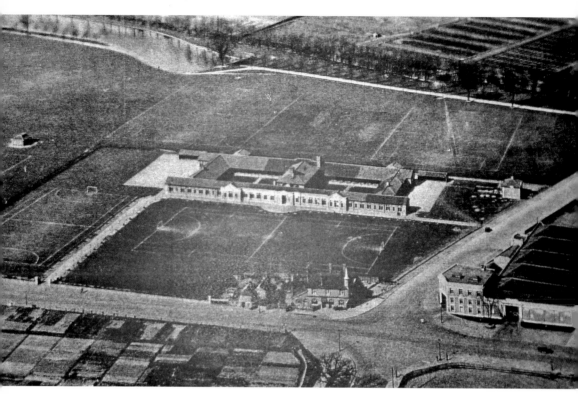

Above: By 1921, as the Becontree estate was taking shape, both Barking and Dagenham each had eight elementary schools, along with the Faircross Special School (rebuilt in 1965). In 1922, the county council opened Barking Abbey Grammar School under the superlative headmaster Col E. A. Loftus. This flourishes today as a comprehensive, albeit at two different sites in Longbridge and Sandringham Roads.

Left: Dagenham's Marley Secondary School for Boys and Girls was built in 1936. With girls upstairs and boys downstairs, they rarely met. The school proved to be a great launching pad for many careers, including sport. In 1970, students of nearby Park School merged with Marley. Its name became Crescent School. A fire in the 1980s destroyed some upper classrooms and led to another name change. It is now the Dagenham Church of England School, and today, is an impressive state-of-the-art place of learning.

The Dagenham County High School was highly regarded as the place for bright students who had passed their eleven-plus. Its alumni included the musician and film star Dudley Moore, Professor Roy Greenslade and many other luminaries. It changed from a grammar to a comprehensive in 1970, and was renamed Parsloes Manor. It is now the Sydney Russell School, a high-achieving place of learning.

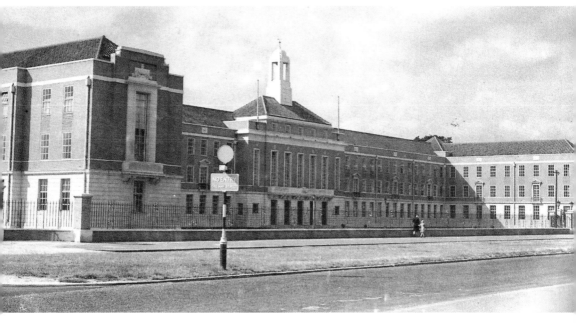

Although the South-East Essex Technical College in Longbridge Road, Barking, is now a place for upmarket apartments; thousands will remember attending this special centre of learning during its lifetime, from 1936–2006. Gone, but certainly not forgotten.

Chapter Ten

The Dagenham Girl Pipers

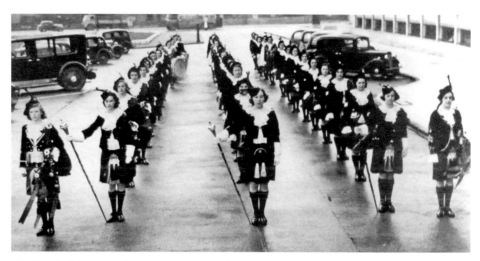

The band of the Dagenham Girl Pipers has become synonymous (along with the Ford Motor Company) with Dagenham. The band was the creation of the Revd Joseph Waddington Graves, who had taken up his position as pastor at Osborne Hall, Osborne Square, Dagenham, in the late 1920s. No one could have guessed that, within a few short years, the Dagenham Girl Pipers would be known the world over.

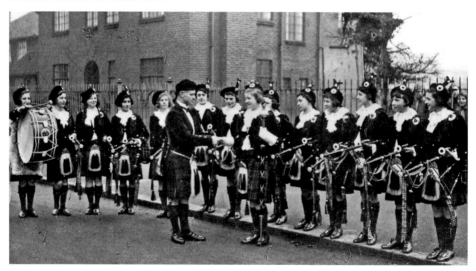

Revd Graves' fascination with Highland dancing and his love of bagpipes led to his dream being realised. The first practice evening was at Osborne Hall in Osborne Square on 4 October 1930. The dozen local, eleven-year-old girls chosen were Margaret Battley, Violet Clark, Gladys Cooper, Gladys Cross, Peggy Iris, Violet Johnson, Joyce Jones, Edna Jordan, Violet Nash, Doris Patterson, Phyllis Seabrook and Edith Turnbull.

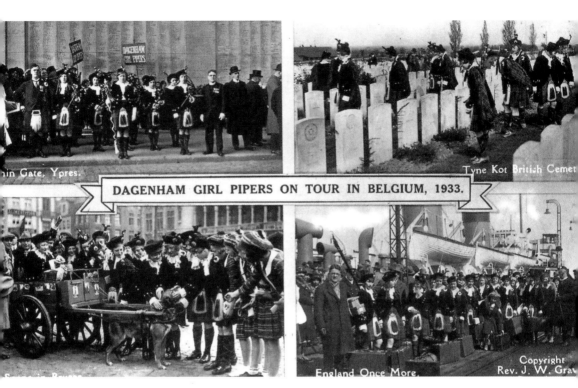

in Gate, Ypres.

Tyne Kot British Cemet

DAGENHAM GIRL PIPERS ON TOUR IN BELGIUM, 1933.

England Once More.

Copyright
Rev. J. W. Gra

Pipe Major G. Douglas Taylor of the King's Own Scottish Borderers was the girls' teacher, and for eighteen months the youngsters practised diligently before their first public appearance in 1932. That first gathering was a huge success. In his 1957 published book, *The Dagenham Girl Pipers*, Alfred H. Haynes described the reaction of the crowds lining the route at their first Lord Mayor's Show in 1932: 'As, led by their 13-year-old Drum Major wielding her mace with all the adroitness and aplomb of a seasoned veteran, the small figures of the Dagenham Girl Pipers marched into view, the crowd literally gasped with amazement. So deafening was the thunderous applause which followed that the *Daily Mail* was moved to say of the girls next day, "They were the best thing in the whole Show." Within a year, the band was playing overseas.

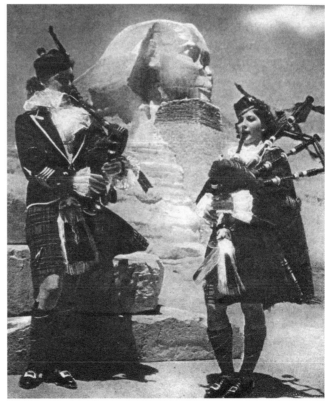

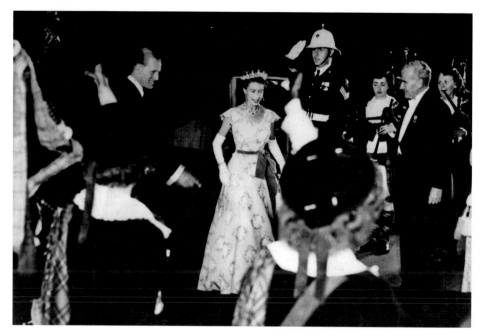

Within a short time, commissions for the band to perform came flowing in. This meant touring throughout Britain, and then to other countries, so the older pipers turned 'professional'. The girls met members of the royal family, as well as presidents, film stars and entertainers from overseas.

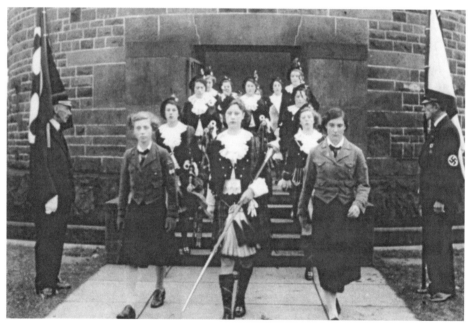

In August 1937, the pipers received a tumultuous reception at the Wintergarten, Berlin. Adolf Hitler watched the performance and told Revd Graves how impressed he had been by the girls' display and 'how he wished that Germany had an organisation similar...' The next morning, the band marched through Berlin and played 'Tipperary' outside the German Chancellery.

Right: Highland Dress.

Below: Peggy Iris, one of the original dozen youngsters, along with Edith Turnbull, having been especially trained by Pipe Major Taylor, took on the job of training the younger recruits, which, by the time war was declared, numbered fifty-three members, divided into four groups. During a medical check in 1938, prior to flying off to appear at the New York World Fair, doctors reckoned the girls were so fit that they would live to a ripe old age. It was then that the famous 'pledge' was made to meet at noon on 1 January 2000 on the steps of Dagenham's Civic Centre. Sixty-two years on, twenty pipers fulfilled their extraordinary promise and enjoyed a glorious Millennium reunion.

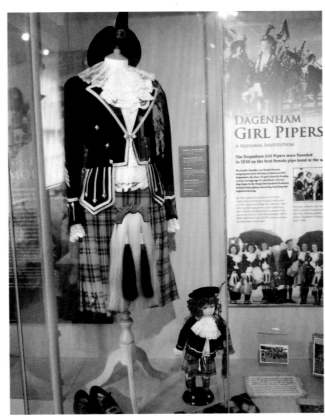

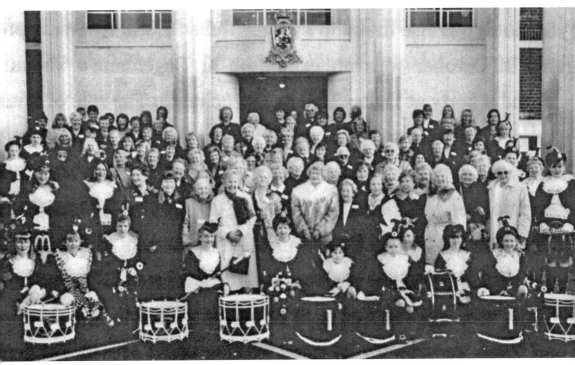

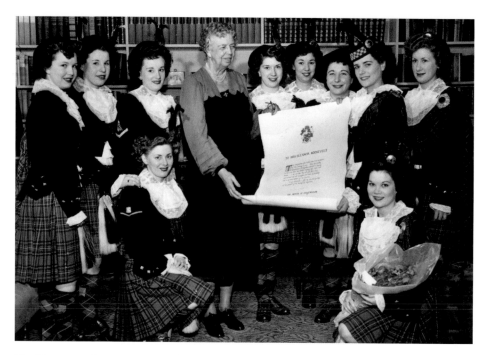

The Pipers meet America's First Lady, Eleanor Roosevelt. Everyone loved the pipers, and their tours of America, Canada, Europe, South Africa and Australia continued. Having visited twenty-nine different countries and performed before numerous heads of state, they also appeared regularly on television and in an Ealing comedy film in 1956 called *Who Done It*, which included Belinda Lee playing a glamorous DGP called Frankie.

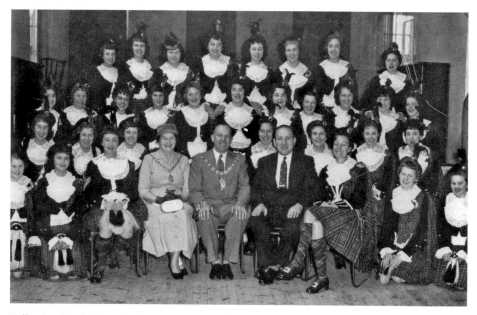

Following Revd Graves' retirement in 1948, the extremely successful agent David Land became administrator as well as MD of the Theatre Royal, Brighton. Sadly, Mr Land died suddenly on Christmas Eve 1995. His son, Brook, now manages the band.

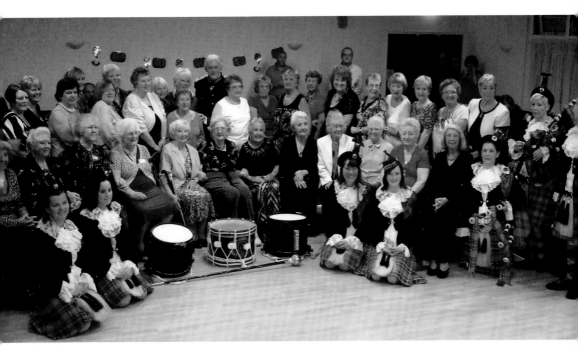

The eightieth birthday celebrations took place in October 2010, organised by the Dagenham Girl Pipers Veterans' Association. It was a wonderful evening at the Dagenham & Redbridge Football Club among generations of pipers. The borough's mayor Cllr Nirmal Singh Gill and pipers welcome guests, including the Lord Lieutenant of Essex, Lord Petre, and pipers' families.

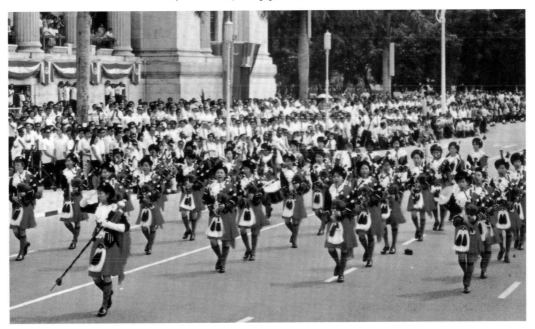

In 1966, Pipe Major Peggy Iris flew to Singapore to form a girls' pipe band. she succeeded wonderfully, and the youngsters were ready to take part in Singapore's National Day Parade. Here we see the band march past the Presidential Podium in August 1967.

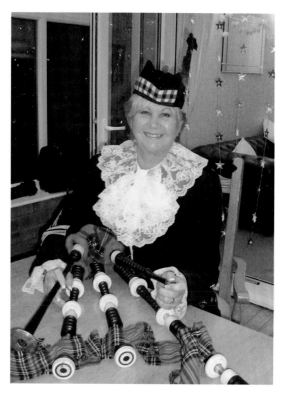

Pipe Major Sheila Hatcher (*née* Nobes) joined the Dagenham Girl Pipers in May 1958 as an eleven-year-old raw recruit. Completing fifty-four years of continuous service, she has held every rank in the band. In her sixty-fifth year, Sheila has never missed a practice session and was honoured in 2014 with the prestigious award of the British Empire Medal.

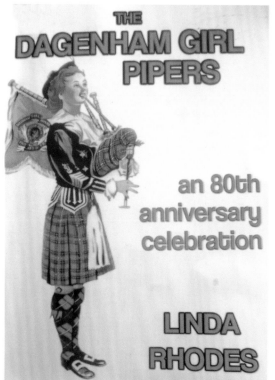

Linda Rhodes, author of the impressive book *The Dagenham Girl Pipers: An 80th Anniversary Celebration*, echoed the words spoken in 1970 by the late Cllr Vic Rusha, the band's first president: 'Rock groups come and go, but the Pipers go on forever.'

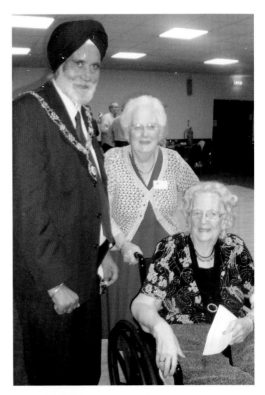

The borough mayor, Cllr Nirmal Singh Gill, with Veteran Pipers Grace Simmonds and Ivy Richards at the eightieth reunion party.

Young Chelsea Fox carries on the Dagenham Girl Piper tradition.

Chapter Eleven
The Ruling Classes and Governance

Historians have written about the Manors of Valence, Marks, Wangey, Parsloes and Cockermouth, on lands belonging to the Manor of Barking. From the catalogues at Valence House Museum, we learn much more about their interesting historical links. Of the numerous local families who have been in the service of the Crown and government over preceding centuries, the names of Fanshawe, Parsloe, Gascoigne, Sysley, Sterry and Hulse, among others, are in the museum's archives.

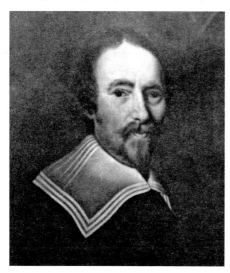

The Manor of Barking was the largest and wealthiest of Barking Abbey's properties. After the abbey's surrender to the Crown in 1539, the estates were sold to Sir Thomas Fanshawe (1628–1705). The Fanshawes owned estates in Barking and Dagenham for around 350 years. As Lords of the Manor of Barking from 1630 to 1717, they and their descendants lived at Parsloes Mansion, Dagenham, demolished in 1925. William Fanshawe, first of the Fanshawe line, is pictured here.

The Sysleys of Sevenoaks bought the manor of Eastbury in Barking around 1572. Clement Sysley, who died in 1578, is believed to have built Eastbury House. His new, imposing mansion was complemented by barns, stables, orchards and gardens, and he was proud of his wood, rabbit warren, marsh grounds and meadows and 50 acres of land, which were sub-leased. Eastbury House has a chequered history, and it is wonderful that it still exists despite the turmoils of modern life. It is still an enchanting building.

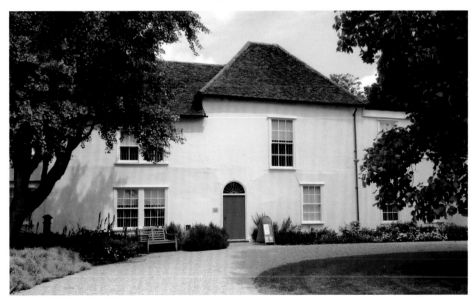

As with Eastbury Manor House in Barking, Valence House is the only surviving Dagenham manor house. Situated in Valence Park, sections of this lovely timber-framed building were identified by English Heritage as dating from the fourteenth century. Part of a medieval moat and some grounds still survive. The estate was named after the de Valence family, who were associated with Dagenham between 1291 and 1342.

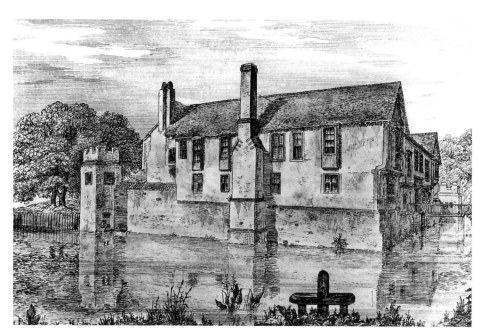

The modern residents of the borough of Barking and Dagenham can only look back in wonder at the pictures of the ancient buildings of the past, now demolished. Many belonged to the free tenement of Barking Abbey, including the Manors of East Hall, Frizlands, Fulks, Gallance, Malmayanes, Jenkins, Marks, Porters, Cockermouth, Eastbury, Westbury, Bifrons and Wangey, among others. Some live on as names of local streets, schools and buildings in the borough.

Until 1700, local government was controlled by the manor court, then by Vestry. Dagenham Parish Council was formed in 1894. The parish became an urban district in 1926, and Valence House was used as offices by the LCC. Dagenham was granted a Borough Charter in 1938. Barking achieved borough status in 1931 and was marked by the 'Charter Pageant' held that year. Barking Council Pageant officials can be seen in the above photograph.

Right: Stephen Arthur Jewers, Barking Town Clerk at the time of the 1931 Charter Pageant.

Below: From its construction in 1936 until 1965, when Dagenham was amalgamated with Barking, the civic centre was the nucleus of administration.The photograph below shows an early view of the Civic Centre.

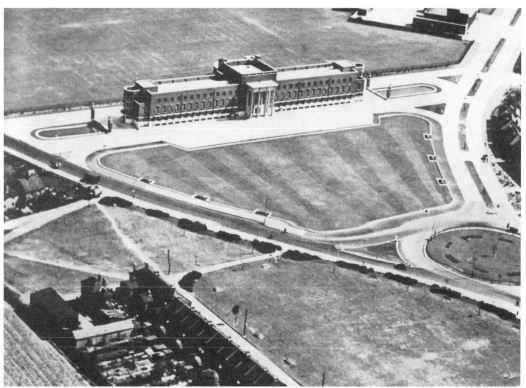

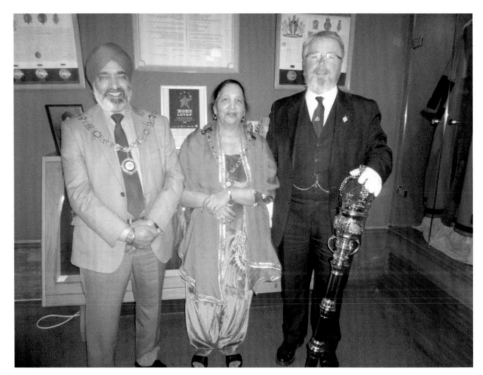

Each year, a new mayor is chosen to represent Barking and Dagenham. During 2013, Cllr Hardial Singh Rai and his wife kindly opened the council chamber and Barking Town Hall to visitors. They are pictured here with Anthony Ward, their mace bearer.

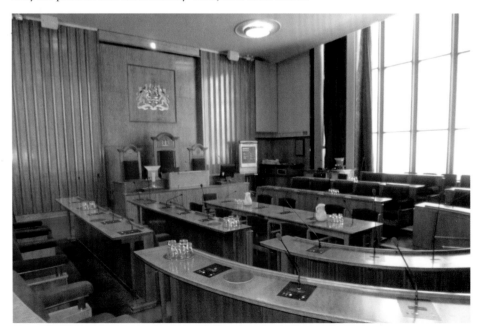

The impressive chamber at Barking Town Hall.

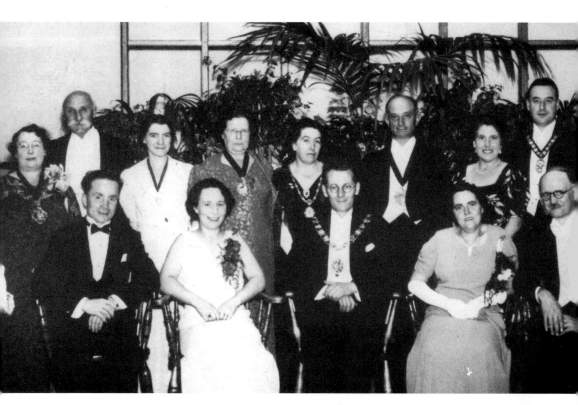

Above: A line-up of Dagenham councillors at their Charter Ball in 1938.

Right: Cllr Elizabeth Kangethe is Mayor of Barking and Dagenham for 2014/15, pictured here with her consort, Kenneth Kangethe.

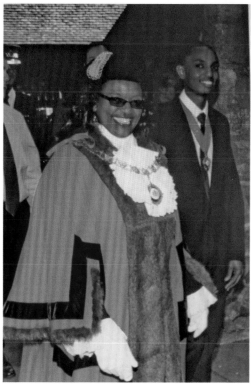

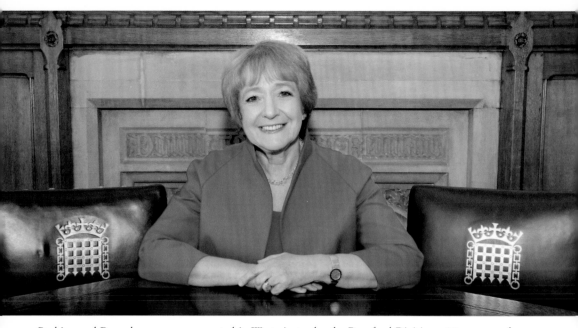

Barking and Dagenham were represented in Westminster by the Romford Division 1884–1945, when the separate constituencies of Barking and Dagenham were created. Pictured is the Rt Hon. Margaret Hodge MBE MP.

Chapter Twelve

Famous Connections

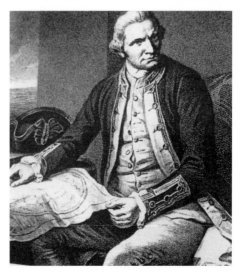

KNOW THE TRUTH
GEORGE
CAREY
A Memoir

The borough has been home to many of the world's most distinguished people. George Carey or, to be correct, the Rt. Revd and Rt. Hon. the Lord Carey of Clifton, is one such gentleman. He became our 103rd Archbishop of Canterbury in 1991. Reede Road was once his address in Dagenham, and his school was Bifrons, which he left aged fifteen. During his time in office, he witnessed immense changes in the Church of England and took part in numerous national events. Retiring in 2002, his name can be seen on the façade of the George Carey Primary School, built in 2011, right in the heart of the new Barking Riverside development.

Capt. James Cook (1728–79), the famous English navigator, married a local girl, Elizabeth Batts, by special licence on 21 December 1762 in St Margaret's church, Barking. The couple produced six children. Capt. Cook bade farewell to Elizabeth in 1777. Sadly, she learned of his murder in Hawaii twenty months later. Several monuments in London commemorate this brave sailor.

Dame Vera Lynn, born in 1917, was a favourite singer worldwide when she became 'the Forces Sweetheart' in the Second World War. Her musical recordings were hugely popular, and two of her songs topped the American hit parade in 1952. Dame Vera lived for a while at her mother's home in Upney Lane, which she remembers well. She said, 'I recall living in Barking very clearly and I have many memories of my time there. I recall going to my neighbour's underground shelter during the war as we could hear the ack-ack guns in the park. It was a very prominent place for the air-raid attacks. I remember my very happy time there with such nice neighbours and I certainly do remember the Blitz. Fortunately, my road didn't get a direct hit, but some were very close.'

The political essayist Jeremy Bentham (1745–1832) was born of upper-class parents and spent much of his happy childhood at the home of his grandmother. In later life he recounted, 'So long as I retained my smell, a wallflower was a memento of Barking, and brought youth to my mind.' His body was bequeathed to University College, London, where it was preserved, and is still on display today. Because the head had deteriorated, it was replaced with a waxen mask.

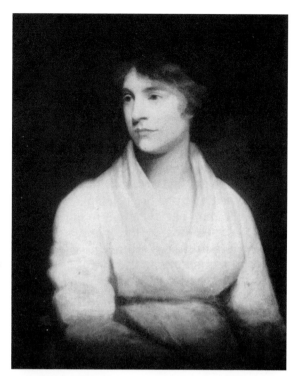

Mary Wollstonecraft (1757–97) died at a young age, but her philosophy contained within her pioneering feminist tract, *Vindication of the Rights of Women*, still shines brightly in the minds of modern women seeking equality. She moved to Chadwell Heath with her family in 1764. After losing his fortune, her father John moved them to Yorkshire. Mary married William Godwin in March 1797 and a daughter was born on 30 August that year. Sadly, Mary died soon after on 10 September. Her daughter, also Mary, married the poet Percy Bysshe Shelley in 1816.

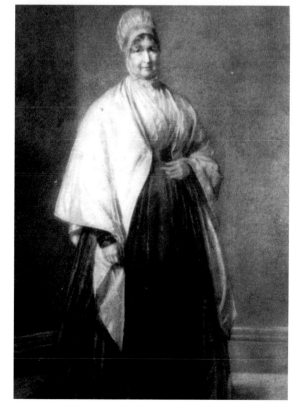

Elizabeth Fry (née Gurney), the Norfolk-born prison reformer, moved to East Ham when she married Joseph Fry in 1800. Becoming a Quaker minister, she worked indefatigably from 1813 for better conditions of women prisoners in London's Newgate. Elizabeth and her large family enjoyed holidays in two cottages at Dagenham Breach. In 1845, she died aged sixty-five. A thousand people attended her burial at the Quaker burial ground in North Street, Barking. Her portrait currently appears on the English five pound note.

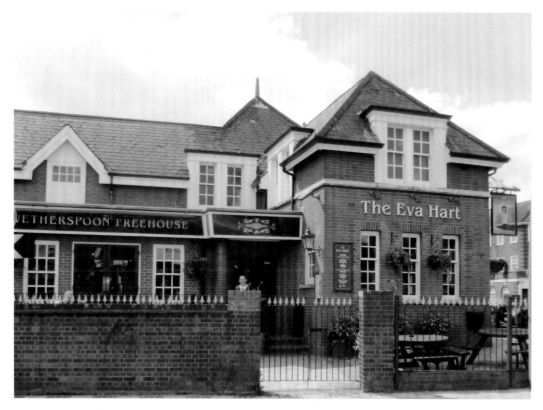

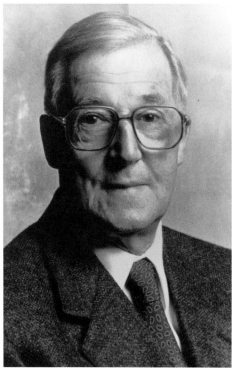

Above: Eva Hart, a survivor of the Titanic, lived in Chadwell Heath. Aged just seven, Eva and her parents were booked on the 'unsinkable' ship. Sadly, Eva's father died during the trauma, but the girl was reunited with her mother following separation in the melée to board the lifeboats. Eva had a successful professional career, eventually serving on the Barking Magistrates' Bench. She wrote about her experiences in later life and died in 1996. A painting of Eva hangs at the Eva Hart pub in Chadwell Heath.

Left: Dressmaker to the Queen is an honour and one that Sir Hardy Amies cherished. Edwin Hardy Amies grew up in Dagenham when his father became land agent to the London County Council during construction of the Becontree estate. Born in 1909, the boy remembered the open fields before the building began. Gaining a place at Brentwood Grammar School, he made long journeys to school, pedalling on his bike to the station and then onward by rail. He was pleased when he became a boarder. He died in 2003.

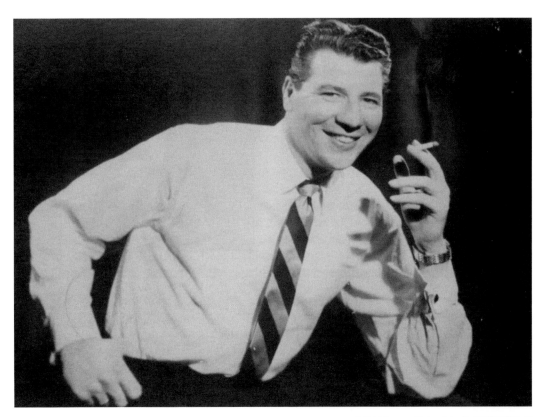

Above: The popular television and variety entertainer Max Bygraves OBE (1922–2012) sang in pubs and clubs of the borough from the time he came to live at Rush Green in 1949 with his wife, Blossom. Max reached the height of success after making dozens of 'singalong' albums, appearing in eight films, presenting numerous TV shows and performing at twenty Royal Variety Performances in the presence of Queen Elizabeth. He died in Queensland two years after Blossom passed away in 2011.

Right: Elizabeth Lord, the novelist, was born in 1928 and lived in Valence Avenue through her childhood. Her local Valence Library was a great source of inspiration and she used to 'haunt the place'. Now, with twenty-seven books to her credit, Elizabeth is still writing sagas set mainly against the background of London's East End. Elizabeth is a long-time member of the Society of Women Writers and Journalists and RNA.

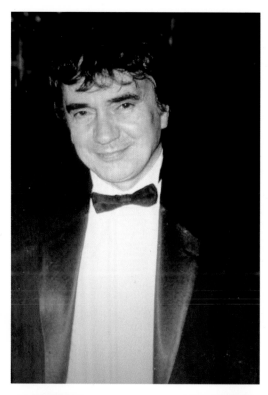

Dudley Moore lived locally, attending the Dagenham County High School (now Sydney Russell). He lived at Monmouth and Baron Roads, Dagenham. Winning an exhibition to the Guildhall School of Music & Drama, he won an organ scholarship to Magdalen College, Oxford. His success was astronomical. He was an accomplished pianist, comedian and a Hollywood actor. On *This is Your Life*, Dudley recalled his fondness for friends and teachers who had made a difference to his life. He never forgot his Dagenham roots. Dudley died in 2002. Here he is pictured at the Grammy Awards in 2001.

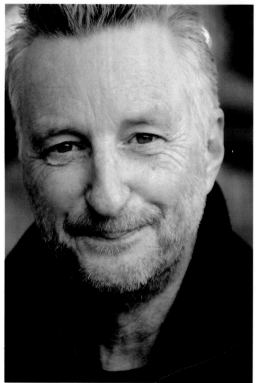

Billy Bragg is well known as the 'Bard of Barking'. This author, poet, songwriter, television celebrity and unofficial politically-minded troubadour reckons he has always felt very fortunate to have grown up in the street next to Barking Park. As he recalls, 'The park gates on the corner we just yards from our house and, once through them, me and my friends were in a world of adventure.' Billy attended Barking Abbey School and after joining up with his school friend, Wiggy, formed a punk band, Riff Raff. By 1982, he was composing songs and toured the UK singing and performing, and by May 1991, the *New Musical Express* described Billy Bragg as 'Britain's finest rock poet'. (*Image courtesy of James Millar*)

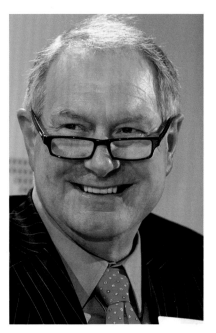

Professor Roy Greenslade is one of Britain's foremost names in the press world. Educated at Dagenham County High (now Sydney Russell), at seventeen he joined the staff of the *Barking & Dagenham Post*. After his three-year apprenticeship, he joined the *Lancashire Evening Telegraph* in Blackburn as a sub-editor and later worked at the *Daily Mail*. His life in Fleet Street was fast, furious and fantastic and as a journalist, he rose to the highest levels of management in a career taking in *The Sun* and the *Sunday Times*, and culminating in the editorship of the *Daily Mirror*. He is the author of three books and is Professor of Journalism at City University, London.

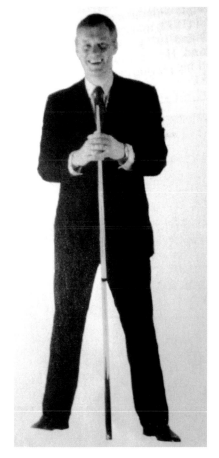

Barry Hearn's name is synonymous with snooker. Born in 1948 at Grey Avenue, he attended Buckhurst Hill Grammar School and later qualified as a chartered accountant. His involvement with snooker began in 1974 as chairman of the Lucania chain of snooker clubs. He formed the Matchroom Co. in Romford, managing some of the world's top snooker players, and has since moved on to promoting boxing, pool, golf, table tennis fishing and other sports.

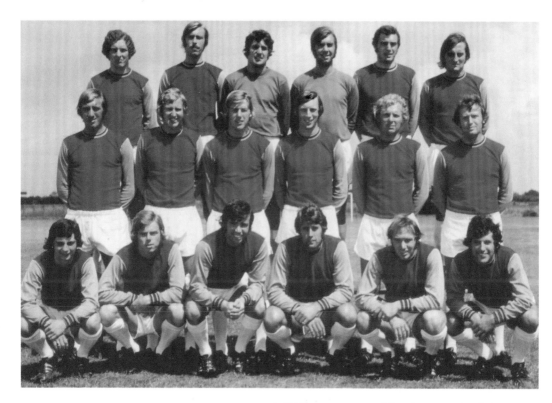

Above: Sports personalities linked to the
borough are legendary: Frank Bruno, Jim
Peters and footballers such as Dick Walker,
Kenneth Brown, Walter St Pier, Sir Trevor
Brooking, Sir Alf Ramsey, Charlie Fuller, Tony
Adams, Jimmy Greaves, Bobby Moore, Martin
Peters, John Terry, Terry Venables, Frank
Lampard – the list goes on. This photograph
taken at West Ham in 1972 is memorable
in itself, not least when we remember how
some of the line-up played in the World Cup
winning team of 1966.

Right: Our 'hall of fame' also includes singers
Jan Burnette, Millicent Martin, David Essex,
Sandie Shaw, actor Ross Kemp, playwright
Johnny Speight, Brian Poole (of Tremeloes
fame) and Mick Nash and his Rockin' Devils,
who backed numerous top rock bands in
the 1970s.